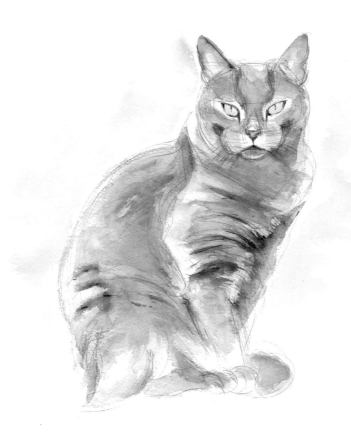

DRAW & PAINT YOUR PET

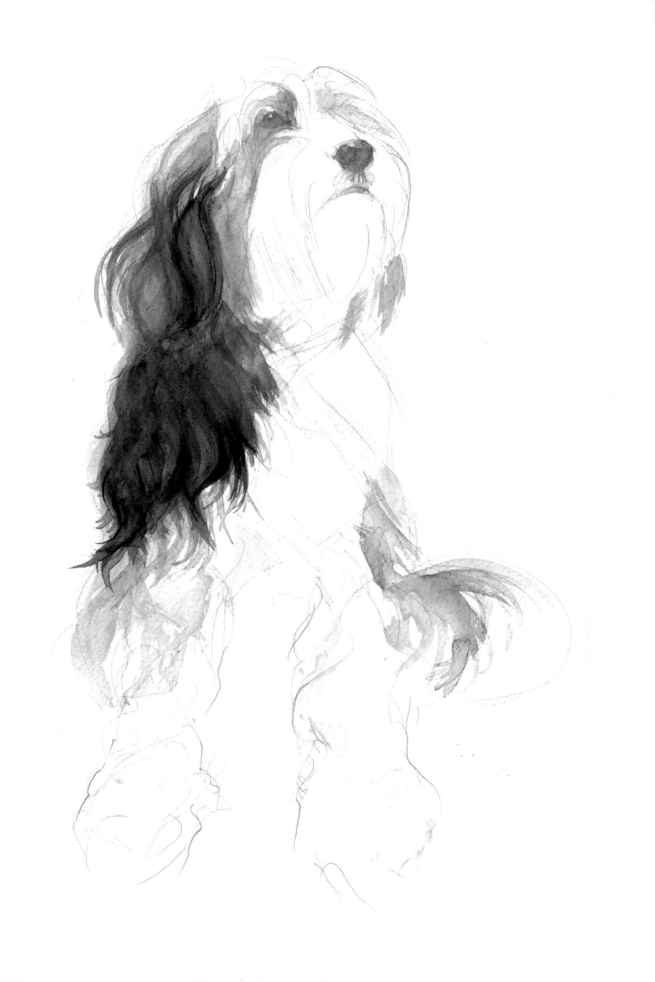

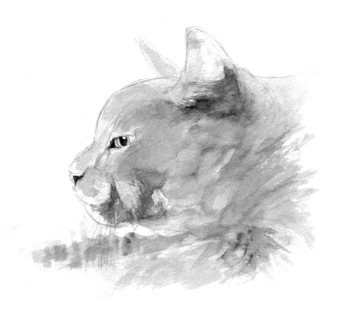

![Collins]

DRAW & PAINT YOUR PET

SUSIE WYNNE

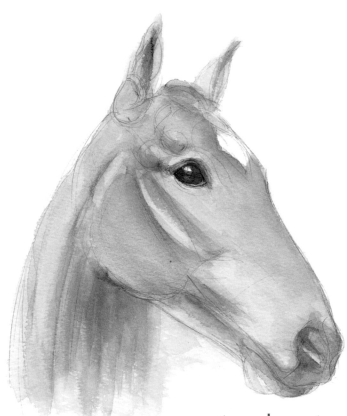

step-by-step paintings in watercolour

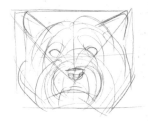

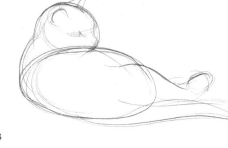

First published in 2001 by
HarperCollins*Publishers*
77-85 Fulham Palace Road
Hammersmith, London W6 8JB

The HarperCollins website address is:
www.**fire**and**water**.com

Collins is a registered trademark of HarperCollins Publishers Limited.

05 04 03 02 01
6 5 4 3 2 1

A catalogue record for this book is available from the British Library

Editor: Geraldine Christy
Layout Designer: Anita Ruddell
Photographer: Nigel Cheffers-Heard

ISBN 0 00 711685 3

Colour reproduction by Colourscan, Singapore
Printed and bound by Printing Express Ltd, Hong Kong

Susie Wynne has produced two videos, *Draw and Paint Your Pet* part 1 and part 2, to
accompany this book. They are available from good art and craft shops or direct from:
Teaching Art, PO Box 50, Newark, Nottinghamshire, NG23 5GY
www.teachingart.com
Tel: +44 (0)1949 844050

AUTHOR'S ACKNOWLEDGEMENTS

I would like to thank Cathy Gosling and Caroline Churton of
HarperCollins and Geraldine Christy for their hard work and
guidance in helping me put all this together. My special thanks go to:
Michael Bond, for his constant encouragement and support; Caro
Skyrme of the Le Mur Vivant Gallery; Heather, Clementine and Iona
Kirby; F. B. Birch; Mr and Mrs McGlone; Rachael Moorhead; Alison
Batchelor; Mark Chard; David Pope; Ann-Louise Dyer; Derek
Cooke; Julian Hare; The Lord and Lady Vestey; Rhonda and John
Jones; Belinda Tapp; Gray Levett of the Nikon Owners' Club
International and Grays of Westminster; Nick, my husband; and L.
Ron Hubbard for his inspirational writing on art.

CONTENTS

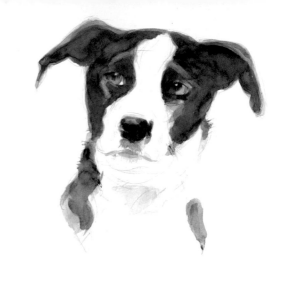

INTRODUCTION

Photo: Gray Levett

SUSIE WYNNE

My interest in drawing and painting began at the early age of around five years old and by the time I had reached nine or ten I spent a lot of my time sketching – mainly horses and dogs. Later I was formally trained in classical piano and voice, but I did not pursue these musical activities with the passion for painting and drawing that seems to have come to me over the years.

This interest in animals sprang up again as an adult when I was inspired to write some short stories for children. I soon took out my sketchpad and created the characters, and found that extremely entertaining and fulfilling. However, I became so involved with the drawing aspect that it became all-consuming. So I decided to take a temporary break from story writing and before long I was painting and drawing during all my spare time. Commissions started coming my way and I found that there is nothing quite so satisfying as to deliver a completed picture of a beloved pet and see the reaction of the owner to one's efforts with the paintbrush!

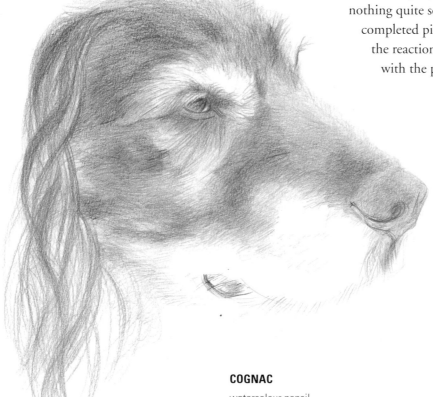

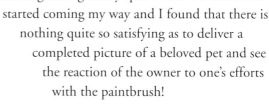

COGNAC

watercolour pencil

Cognac is a rather elegant Basset Fauve de Bretagne. I find drawing close-up pet studies such as these very pleasing, producing an effect that can look quite dramatic. I enjoy working with watercolour pencil for this kind of detailed work, which is a very different style from my watercolour paintings.

PRACTISE YOUR DRAWING

In continuing my drawing and painting I have developed my skills to a standard I did not dream I could reach at the outset. I think the advice I would give to a beginner is to establish your drawing skills well first of all before coping with how to paint. I knew a professional artist in the USA who had a good career as a painter of oils, but, after seeing my work, he told me he was going to attend drawing classes again. I was not only extremely flattered, but very relieved that I had kept my drawing skills finely tuned. I have driven myself very hard in order to do so.

So, with this in mind, I have emphasized the importance of drawing and sketching throughout this book and I do hope you will find the examples illustrated helpful and inspirational.

WATERCOLOUR PAINTING

When I first approached painting with watercolour I remember people commenting on how difficult a medium it is to control. Being the sort of person who likes to take on a challenge, however, I decided to launch myself fully into using watercolours. While I found watercolour painting very difficult at first I soon discovered that the way to approach a subject is to try to master just a little at a time. When you feel competent at doing that small amount you can then move on to the next stage. Practice is the key word and is one

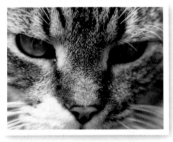

RAMBO'S EYES
watercolour pencil

Cats' eyes are unique in their beauty and drawing them provides an excellent exercise in getting to know the shape and general nature of a cat's facial features. The intense yellow-green of Rambo's eyes is emphasized by the soft texture of the surrounding fur built up in layers with pencils.

that I reiterate often: this is the only way to familiarize yourself to the point of being in control of a technique. Even now I find some subjects can be tricky in the extreme, and frustrating to paint, but I always persevere until I am successful.

With watercolour painting you will learn only from experience. Do not worry if you have to waste paper and paint in an effort to achieve a good result. This is all part of the learning process and, while you may want to pull your hair out at times, remember that a worthwhile activity usually requires hard work.

LEARNING FROM PAINTERS

Another valuable step to take in your progress as a painter is to visit art galleries. Especially look at the work of the Old Masters, who painted with breathtaking expertise. These beautiful works of art are uplifting as well as inspirational.

Drawing and painting is a rewarding occupation that might begin simply as a hobby, but then turn into an all-consuming passion. When this happens I know you will agree that nothing compares with the world of creativity. Enjoy your drawing and painting!

LORD ALFIE

Lord Alfie is a fine aristocratic Norfolk terrier and I have had the great pleasure of painting him in both watercolours and oils. This particular pose of him in watercolours portrays his refined and dignified character well! I used Yellow Ochre, Burnt Sienna, Raw Umber and Lamp Black for the range of rich colours in his coat.

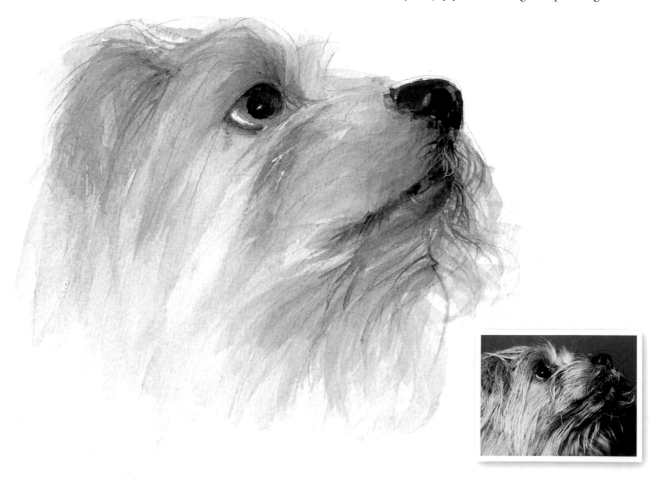

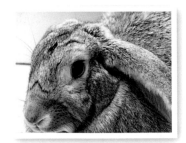

SHERLOCK

watercolour pencil

Watercolour pencils are ideal for fine detailed work. This picture of Sherlock was made using Silver Grey, Blue Grey, Light Pink and Black coloured pencils. Sherlock is a lovely blue-grey lop-eared rabbit, so I used the Blue Grey and Silver Grey pencils alternately, one over the top of the other.

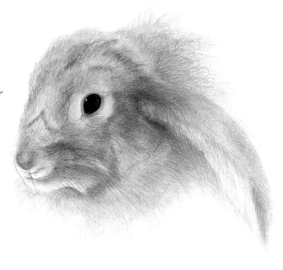

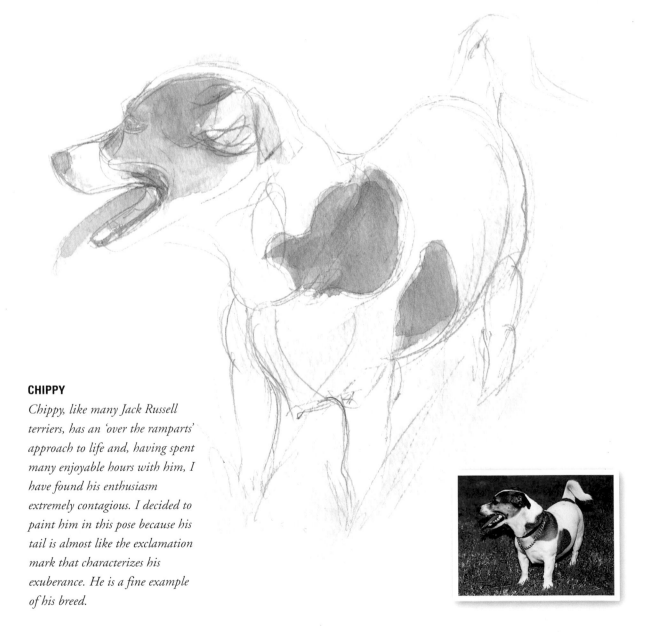

CHIPPY

Chippy, like many Jack Russell terriers, has an 'over the ramparts' approach to life and, having spent many enjoyable hours with him, I have found his enthusiasm extremely contagious. I decided to paint him in this pose because his tail is almost like the exclamation mark that characterizes his exuberance. He is a fine example of his breed.

MATERIALS

I have kept the materials for the contents of this book to a minimum. This is not only for the sake of simplicity for beginners who are being introduced to the subject, but I think it is also a good exercise for more experienced artists to produce work with a limited range of colours and equipment.

As with most subjects, if you are new to drawing and painting you may find that you are faced with an unfamiliar vocabulary. Art techniques are often described in specific terms that may appear confusing to you at first, but once you have begun to understand these terms you will find that they are useful to you. Do not hesitate to consult art reference books for help in clarifying any term or technique further. You will progress more quickly when you understand how both techniques and your materials work for you.

My mixing palette with the ten basic colours I use in the book as tubes of watercolour.

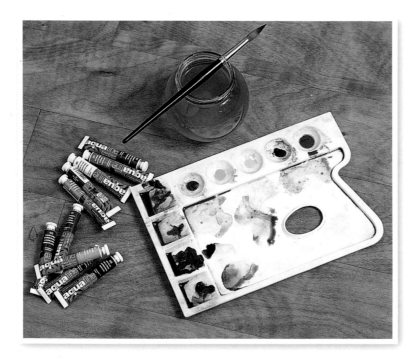

WATERCOLOUR PAINTS

Artists often use the term 'pigment' when referring to colour. This is the source powder obtained from the earth, plants, animals or minerals, or man-made synthetic substitutes. The powder is compressed and mixed with a binder, then either sold dry in little square cakes referred to as pans, or half pans depending on their size, or as moist paint in tubes.

The best watercolour paints are those known as artists' colours. These are of a finer, purer quality and give more vibrant results than the slightly lower grade students' colours. However, for beginner painters, I recommend students' watercolours as they are less expensive. Paints from Daler-Rowney's Aquafine range of students' colours are shown here.

I use watercolour tube paints because I find them easier to work with than the dried watercolour pans. This is a personal preference, however, and you may find pans more suitable. However, if you use

watercolour tubes you will find you need only a small amount to mix with water because the pigment is strong. Tubes can be bought singly or in boxes of ten, twelve or more. You can start with a small pack of basic colours and add to them gradually by buying single tubes.

I have used the following ten tube colours throughout this book: Burnt Sienna, Raw Sienna, Burnt Umber, Raw Umber, Yellow Ochre, Sap Green, Alizarin Crimson, French Ultramarine, Lamp Black and Chinese White.

I use quite a large plastic palette as I find it helps to have plenty of space in which to place the colours before mixing. Always wash your brush well in clean water before and after mixing and change the water in your jars regularly to avoid any hint of muddiness in the mixes. Keep a piece of kitchen roll handy to mop up any splashes that will inevitably occur in your enthusiasm.

Take your time when mixing and practise before starting to paint. If necessary allocate half a day, or as long as it takes you to become confident. Learn the basics of colour theory and make a colour wheel as a reference to familiarize yourself with the rules of mixing.

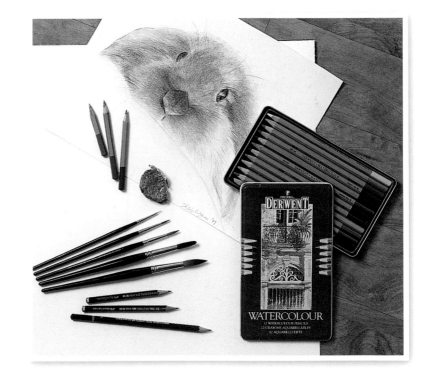

The five watercolour sable brushes I recommend (sizes 00 and 000, and nos 3, 8 and 11), HB sketching pencils, a putty eraser and a selection of watercolour pencils.

BRUSHES

I have used only five brushes throughout the book. The round brushes that I prefer are sizes 00 and 000, and nos 3, 8 and 11. The size 00 and 000 brushes are the smallest ones and I use them for very fine, detailed work. I favour sable brushes made by Daler-Rowney. Although the sable ones are more expensive it is worth spending that bit extra because sable really are the best to work with. I find them much more pliable than synthetic brushes; they hold moisture better and therefore make controlling the paint easier. If cost is a major factor to consider, however, you will find that synthetic brushes are quite adequate, and I have used many in the past, especially in my early years as a watercolourist.

Sometimes a vast array of brushes of all shapes and sizes is somewhat overwhelming to the beginner. Whatever brush you decide to buy, though, always remember to check that the tip of the brush

forms a fine point when wet. If you have any doubts you will find that the assistants in a good art shop will help you to choose.

Once you have become familiar with the types of brushes suitable for your particular type of work, and are competent in using them, you will start to understand how watercolour can vary by using different types of brushes for different types of paintings. Landscapes, for instance, require bigger brushes for colour washes that cover a larger area than those for portraiture. Concentrate on learning just a little technique at a time and become comfortable with that and the types of materials needed; then you can progress to the next step.

Always work with a clean brush before applying any colour and at the end of your working day wash it out well with warm water and a mild soap. Brushes come with plastic covers and you should keep these and replace them after use; they will help retain the shapes of your brushes.

TIPS

o Keep your working area clean, tidy and orderly, with watercolour pencils and paints in storage boxes.

o Locate your work space away from distractions. If your attention is being taken up by something else get it done so that you can concentrate fully on your drawing and painting.

PAPER

Watercolour paper is sold in single sheets or in pads or blocks. The blocks are more expensive and are formed of sheets compressed together; each sheet can be eased out with the blunt side of a knife via a little unstuck area. You will see the term 'cold pressed' used and this is the type of paper recommended for beginners, as it has a semi-rough surface. It is often known as 'Not' and this means that the paper has not gone through the process of hot pressing. It is suitable for washes and line work as it has a slight texture.

My camera, watercolour paper blocks and sketchpads.

WATERCOLOUR PENCILS

I have used Daler-Rowney Derwent watercolour pencils in this book and these come in presentation packs of 12, 24, 36 or 72 assorted colours. However, they are also sold singly and this is probably the best way to buy them because with a pack of pencils you usually find that there are many colours you do not wish to use. Make your selection with reference to a particular pet and buy more colours as you need them.

Rambo, Susie's cat, is a regular bystander when Susie is at work.

Make sure you have a good supply of lead pencils. Pencil grades range from hard, thin leads to soft, thick leads. The former are useful for fine work and the soft, thicker leads are ideal for covering wider areas and non-detail work. I prefer using an HB pencil for drawing for watercolour since it does not smudge into the paint mixture.

OTHER ESSENTIALS

You will also need a putty eraser and a good pencil sharpener.

I also find a camera an essential piece of equipment for capturing reference photos of all types.

Always work in good light, using a daylight bulb if you are not in a naturally lit studio space. A daylight bulb produces a true, natural colour as opposed to conventional yellow light bulbs.

Easels range enormously in size and price and as a start you can use a table easel.

Keep your working area orderly. Following this rule will help you work more easily and with greater concentration. A disorderly studio will not only slow you down, but will distract you in your creativity.

BASIC SKETCHING

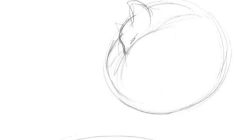

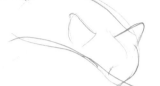

An artist first has to be able to observe his or her environment well. You will find that your observation skills will improve markedly if you get into the habit of sketching regularly. In fact, sketching often and every day is a vital activity to help you progress in your drawing skills. Buy a small hard-backed sketchbook that you can carry around with you and use it as much as you can. Keep all your sketches and watch how your drawings get better with frequent practice.

LOOKING AT SHAPES

Even though this book is all about drawing and painting animals it is important to train yourself to look at the shape of everything around you. I would recommend you first of all just take a walk in your neighbourhood or local park and look at the basic shapes of buildings, trees and flowers and consider them from a new viewpoint. How would you start sketching that flower, say, as simply a shape? Spend time on this activity by just observing and working out in your head the shapes of various things you see. Then, on your next walk, take your sketchbook with you and make drawings and written notes to reinforce what you have observed.

Once you have trained your eyes to look at the things around you in terms of shapes you will find that you can look at your pet more objectively. For instance, notice how cats and dogs tend to curl themselves up when they are asleep or sitting, and you will soon start to see them as spherical shapes. Forget about any detail at this stage; the idea is to capture an impression of the animal that allows you to recognize its basic form. In doing so you may also surprise yourself as you start to draw typical poses that capture the spirit and character of the animal.

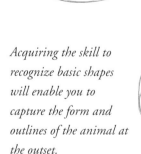

Acquiring the skill to recognize basic shapes will enable you to capture the form and outlines of the animal at the outset.

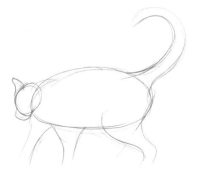

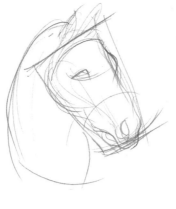

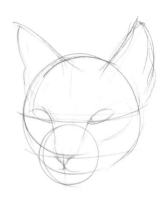

Simplify drawing an animal's head by using basic shapes. They will create an underlying structure you can build on.

HEAD SHAPES

When you focus more specifically on a portrait drawing of an animal you must observe it carefully, looking for the component shapes. The head is always a good place to start, so make a study of it. Simplify the exercise by using basic geometric shapes such as circles, ovals, cylinders and cones, and forget about detailed outlines. Place yourself at different positions around your subject so that you are looking at it from all angles. Figure out if the basic outline of the head full frontal is square or round. It may change as you move to a different viewpoint – a head can be cone-shaped if you look at it in profile, for instance. Practise these head shapes for different animals in your sketchbook over and over again, drawing them routinely until the pencil becomes an extension of your hand.

Remember that each animal is an individual and that you must observe and consider it as such. Getting the overall shape of the head right will enable you to add further guidelines for the features. The animal's features, too, can be drawn as geometric shapes at this stage and unless you observe them correctly you will have difficulty in making a realistic portrait. You can use a triangle within the circular head shape to line up the eyes and the nose, and the ears can be just simple little triangle shapes.

BODY SHAPES

Take a look at the body now and figure out whether it is cylinder shaped, oval or otherwise. Again the body of an animal will look different when it is sitting or lying down from when it is standing.

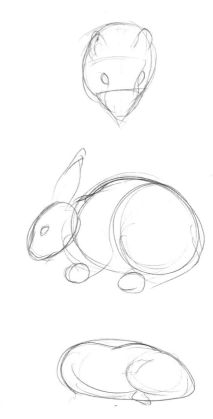

Then move on to the limbs. They too are made up of a series of smaller shapes. A paw can be a lot easier to depict if you first of all draw an oval shape, closely observing the particular cat or dog. Although paws can look fairly simple, they can be tiresomely tricky to get right at times and if you use this principle of basic geometric shapes you will have a foundation on which to add detail later.

Some knowledge of animal anatomy will also be helpful in enabling you to place shapes to represent the muscles, for instance, which give the animal its build and control its movement. By drawing these shapes initially as a routine feature of starting a pet portait you will find that your powers of observation increase too and you will be recognizing and placing shapes more quickly and accurately the more you draw.

It is also helpful when you are planning a composition to place a shape around the animal. Drawing a cat or dog inside an triangle can enable you to see the negative spaces of the shapes, helping you to check the overall proportions.

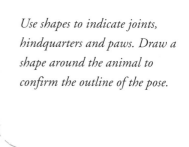

Use shapes to indicate joints, hindquarters and paws. Draw a shape around the animal to confirm the outline of the pose.

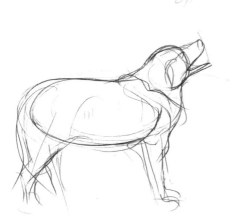

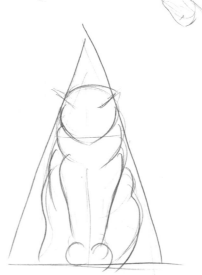

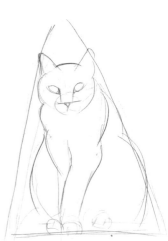

MOVING SHAPES

Sketching moving animals can be quite daunting at first, but it is useful to do so to increase your general observational and drawing skills. Visit the park and notice the dogs on their walks. Your outlines need not be detailed. Just get used to sketching the cones and circles that encompass the head, and the triangles, say, for the ears and quickly pencil in the bodyline while the dog is running or bounding about. You will have to be quick because the shapes will be constantly changing.

Horses can be especially challenging. They look complicated to draw, but if you remember that their bodies are simply a series of shapes in motion and in different positions then you will find that your time spent drawing them is both rewarding and enjoyable.

Take yourself off to the local zoo! Have some fun sketching the elephants or giraffes. Take a big sketchbook and observe those lovely simple shapes. You can use cylinders for the different sections of the legs and a big oval shape for the body.

Keep your sketching up every day. If you continue to follow this method of drawing it will soon become second nature to you and you will make progress as an artist.

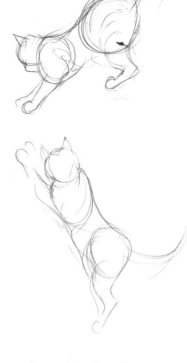

Make rapid sketches of moving animals, thinking only about the changing shapes you see. This will increase your skills and confidence.

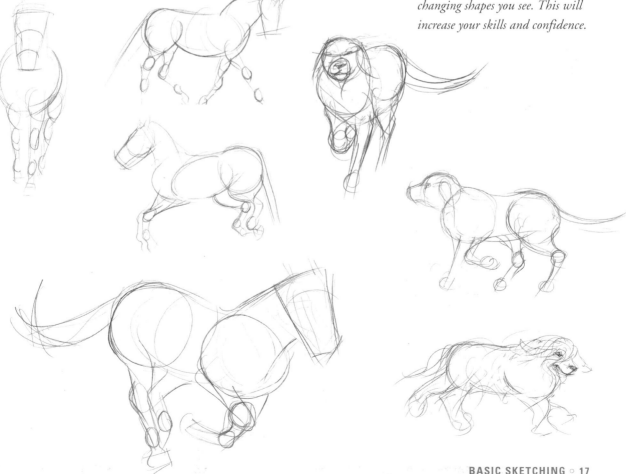

WATERCOLOUR TECHNIQUES

Painting a picture for the first time can be overwhelming for a beginner, but if you know how to use your materials the process becomes much simpler. I use two kinds of media – watercolour paints and watercolour pencils. In this chapter I shall introduce the basic techniques for using these. It is vital that you become familiar with these techniques so that you can achieve the results you are striving for when drawing and painting pets.

The main point I want to stress is that you must expect to put in a great deal of practice. If you are willing to dedicate part of your day to drawing and painting then you are bound to improve.

USING WATERCOLOUR

Work always with clean jars of water at the ready and wash your brushes regularly after use. Always use small amounts of colour, well diluted, and when applying it onto paper use your brush to brush the water and pigment until there is no excess left on the surface. If you apply too much a little pool will develop, leaving an unsightly hard edge when dry. One way to avoid a hard edge if this does happen is to use a sponge or tissue to soak up the colour.

The two main techniques in watercolour are wet-on-wet and wet-on-dry. Wet-on-wet means applying colour on an already wet surface and wet-on-dry means, of course, painting on a dry surface. If you are completely new to this medium then I would suggest that you start by familiarizing yourself in painting wet-on-dry pictures.

Wet-on-dry

This method involves building up layers of colour with a slightly stronger pigment, or sometimes the same mix that was laid down before, allowing each layer to dry completely.

WET-ON-DRY

This technique is an effective way of building up tone. It is used here to create the form of a cat's ear. A first wash is applied over the whole ear area, then left to dry. With a second layer some shape is created. When this is dry a darker layer is added to complete the effect.

When starting a painting wet-on-dry I deal with the tones first of all. Take a look at your subject and notice where the shadows are. You can create these beautiful effects with watercolour with just a little diluted pigment. Paint your first layer carefully, then allow this to dry completely. Then wash out your brush, put clean water in your jar and apply the next layer of colour, keeping it watery, though with slightly more pigment. Continue in this way, adding wet layers on dry ones, until you have reached the tone you require.

Wet-on-dry can also be used for more colourful parts of your picture. Fur, of course, is a prime example. Paint in the dark tones of the fur first, then let it dry before applying your next layer. With long fur you can paint one strand in this way and, when you paint the next strand that falls just over it, the build-up of pigment over the first will give you the effect you want.

Wet-on-wet

Once you have gained confidence with wet-on-dry it will be a natural step to undertake wet-on-wet. Wet-on-wet can be unpredictable and you need to know what you are doing. The first rule is to start on a small scale. It is also useful to place some discarded watercolour paper at the side of your picture so that you can try out the technique. Always be watchful of how your watery paint is behaving on the paper because unwanted hard edges can easily be produced. Caught unawares and not there to act quickly, you will ruin a painting.

With wet-on-wet technique the colour will merge rapidly into the already wet surface. As a first step, dampen a small area with a first layer of colour, or even just clean water, and then apply a small amount of diluted pigment. Try this and see what happens. Once the colour has gone onto the wet surface you can then control it with your brush and help it along by taking up some of the moisture in the brush or pulling it along to a fine point. Or you can spread it out until it reaches a dryer part of the paper and brush out any hard line that will appear.

Wet-on-wet is particularly useful for producing the impression of soft texture. In this example a first wash has been applied to the cat's head and a second layer added before the first is dry. Again before the paint dries, lines of darker colour are added to create tabby markings on the head that merge softly and look natural.

USING WET-ON-WET FOR FOLIAGE

This is a very simple method of creating foliage for backgrounds to your pet paintings. Simply use a brush to 'pull out' the shapes of leaves from the wet paint.

I find wet-on-wet technique ideal for backgrounds such as foliage. For foliage I usually paint a general small area of green, well diluted, into the area I need, but without adding any more mix I use the tip of the brush to shape out sporadic individual leaves.

As you progress you will find that it is fun to mix colours on the paper rather than in the palette. When you graduate to this level make sure you work with a very small amount of pigment, well diluted. Too much colour at too early a stage will make a painting looked daubish.

COMBINING TECHNIQUES

You can, in fact, combine both techniques. For instance, when painting blades of grass, you can paint these in with a fine size 00 brush with a watery mix of green onto a dry surface. Then, before it dries off, paint through, say, half of it with a clean, larger, round brush, which softens the outlines and creates a lovely loose effect. Experiment with this on discarded paper and find out what works best for you.

COMBINING TECHNIQUES

As you progress you may find it useful to combine wet-on-dry with wet-on-wet. The basic fur shapes of this King Charles spaniel's ear were painted wet-on-dry. Then the paper was dampened and wet paint added. Individual strands of fur were pulled out from the wet paint with a fine brush.

USING WATERCOLOUR PENCILS FOR FUR

Watercolour pencils are ideal for drawing a precise impression of fur. Use a sharp pencil to hatch short diagonal strokes, then cross-hatch with another colour for tone. A third colour cross-hatched on top creates realistic-looking texture and pattern. Keep pencil pressure light.

USING WATERCOLOUR PENCILS

You can use watercolour pencils most effectively to build up fur texture, though the technique requires patience and can seem laborious at times. However, you will be rewarded when you see a snapshot of your pet transformed into a realistic portait.

When using watercolour pencils make sure that they are well sharpened. Always use a light touch and gradually build up the pressure as you progress with layers of colour. I work with them dry mostly, and occasionally use a damp fine size 00 brush to bring out the odd strand of fur. After applying the first layer I work the pencil in short strokes in the direction of fur growth until I have built up a second layer. For the darker tones in the fur I use a cross-hatching technique. This means working the pencil in another direction than previously used, either horizontally, vertically, or diagonally. You can create an impression of every strand of fur having been drawn individually by laying the colour down as I have described, but occasionally drawing the odd single strand of fur.

If you make an error use a putty eraser and if you have kept to the policy of applying the lines lightly any unwanted marks will be far easier to remove.

TIPS

o Always keep a spare set of pencil sharpener blades. It is very frustrating to run out when you are in the middle of a picture.

o Keep old watercolour pencils in a spare box. Even virtual stubs can be a good source of colour when the art shop is closed!

o Put your pencils upright in an old can or jar while working on a picture to avoid dropping them and breaking the lead.

USING PHOTOGRAPHS

Photographs provide an instant record for the artist and a good camera with a decent lens is a useful tool to have in your working kit. A series of photos makes wonderful back-up if you are doing a detailed study, though I would say that to rely on them to the exclusion of all else is not the best way to progress as an artist. Seeing an animal in front of you in the flesh is ideal and allows you the opportunity to take out your sketchbook and make notes with your drawings. However, if you combine your sketching with photographs, you can go back to your studio and indulge in your picture with more confidence.

USEFUL REFERENCE

Use your camera to record details that you find difficult, perhaps photographing from different angles. It gives you the opportunity to capture features, especially facial features, for accurate reference. Photographs are valuable for understanding the detail of an eye, or nose, say, particularly if the animal in front of you is constantly moving. Remember, however, that photographs do not reproduce your subject in three-dimensions. A cat's facial bone structure, for instance, is quite marked in real life, but in a photograph this is often completely lost. Similarly, the detailed musculature of a horse can be lost in a photo. That is why I stress the need to observe the animal from life if at all possible. I have spent some very pleasurable moments sitting and sketching horses, for instance, which keep

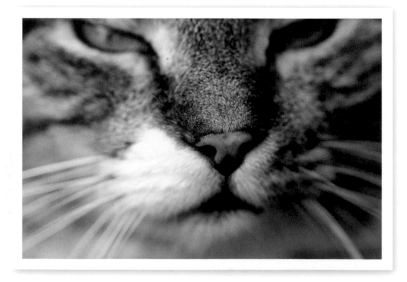

This close-up photograph focuses specifically on Rambo's nose and mouth. This enables me to draw the shapes correctly and confirms the difference in markings on either side of his mouth.

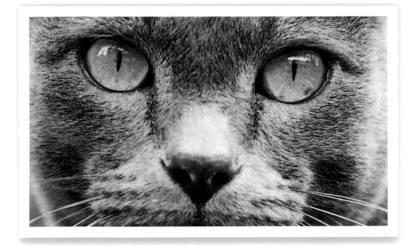

Different shades of colour in Mr Tibbs' eyes are evident and give the opportunity to mix variations into the base yellow colour. Individual fur strands, the lines of whisker growth in the muzzle and the nose make a good study in itself.

reasonably still, and my photos have served to complement my sketches. Certainly if you want to paint a particular pose a camera is ideal for recording what may be a fleeting moment.

PRACTICAL CONSIDERATIONS

When it comes to physically taking a photograph use a good quality camera and lens. It is well worth the outlay and if you are unsure as to what equipment is most suitable for you the staff in a reputable camera shop will give you practical advice and will be easily able to fit your needs.

To avoid camera shake bring your elbows in close to your sides and exhale while you click. If you can, take your photographs outside so as to duplicate the true colour of the animal's fur.

If you use flash make sure the flash unit is not in the line of the eyes, otherwise this will produce red-eye. Some flash accessories can be attached so that they are higher than the camera, so they are worth considering. Flash can alter colour, so I would advise you have your photographs hand printed at a professional processing laboratory.

Getting an animal to sit still for a portait shot is not always easy, but the more photos you have the more you are likely to capture a good likeness. Make friends with the pet and try to photograph it from a variety of angles so that you have a real idea of anatomy and features.

REASSURING THE SUBJECT

It is also important to remember that some pets are terribly nervous about the whole procedure, so spend time getting to know him or her. Establish the friendship and trust before you thrust a huge lens in his face. This will prevent time lost on trying to retrieve a nervous animal from behind a bush or up a tree. Conversely, the over-exuberant puppy, say, will find the camera lens irresistible. On one photo shoot I called the pet's name and he promptly galloped up to the lens and licked it with great fervour!

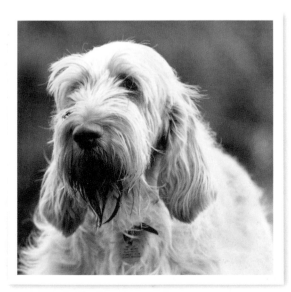

Photo: Ann-Louise Dyer

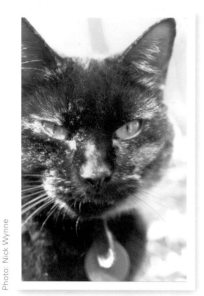

Photo: Nick Wynne

The sun is shining on one side of this cat's face, creating attractive highlights (above). A photograph like this will help me place lighter washes in these areas and darken the colour where appropriate.

I used this photograph (right) as reference for the demonstration on page 92. As well as capturing the pose it provides information about the wall, background and shadows.

WORKING FROM PHOTOGRAPHS

As photographs capture light and shadow they provide a record that you can refer to when you have been unable to sketch these details. This is useful not only in producing a simple portrait of a pet, but when you wish to include a background and have concentrated your drawing on the animal itself.

Other photographs can even inspire a particular style of painting. Out-of-focus bluebells in the foreground of one photo seemed to beg the hand of a watercolourist and thus I was inspired to paint *Bella Amongst the Bluebells* on page 90.

Working often on a commission basis, I have been confronted with many different types of photographs of pets. I have sometimes been assured by an owner that they have an ideal picture but, unfortunately, what may be a characteristic shot is not necessarily

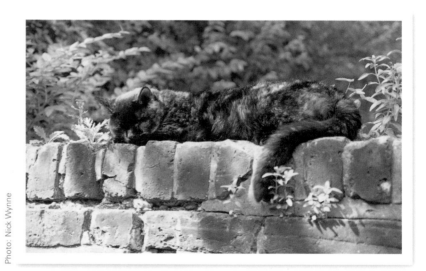

Photo: Nick Wynne

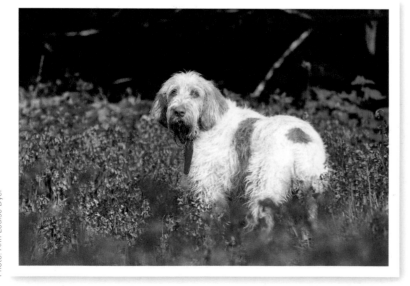

Photo: Ann-Louise Dyer

This is the picture that inspired me to make the painting on page 90. It shows Bella enjoying her country life and the bluebells provide a perfect setting. Bella's mistress, Ann-Louise, is a highly skilled photographer and she has caught some of the dog's character and personality in this photo.

I took this photograph of Millie because I wanted to capture the shadows and colour gradations of her coat. I also loved the whole outline of her body as she grazed, which is quite different from when she is standing with her head up.

suitable reference for producing a painting. If at all possible always try to see the animal yourself, so that you can make your own sketches and take your own reference shots. It is essential that the photographs are in focus as it is impossible to guess markings and colours even if you have a good knowledge of a particular type of animal's anatomy. Also make sure that you can see the animal's features clearly. A photograph of a cat miaowing, for instance, does not provide suitable reference for the set of its mouth.

Sometimes you may be asked to produce a painting of a pet that has died. In such cases try and obtain as many photos of the animal as possible so that you have adequate reference to work from. It is a hard-earned ability to capture a pet's individual personality under these circumstances and you will also need to be sensitive to the owner's feelings.

To produce a good painting of a pet takes observation, patience and research, but if you are willing to do this you will find the results both fulfilling and rewarding. Photography can play a major part in this process.

Hamsters are very quick movers, so a good photograph is helpful when drawing these small pets. This picture of Sweetie shows her round and protruding eyes, which can be difficult for a beginner to observe and sketch accurately.

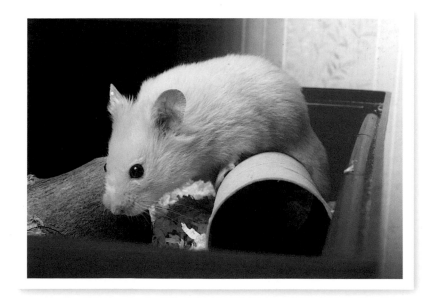

ANIMAL FEATURES

I never tire of observing and drawing animal features. One of the encouraging points about working as an artist is that your observation increases to such an extent that you begin to notice much more than you ever did before. The more you draw and paint the greater your perception for detail becomes and you will see the subtle differences between the features of individual animals. Soon you will find that these observations lead on to inspiration in their own right. Your attention will focus not only on the particular shape of a paw or the bend of a hind leg, but how light creates beautiful shadows and interesting colour changes. The following pages point up the great variety of features in the animal world.

NOSES

Beginners sometimes find that noses are surprisingly difficult to draw and paint, but you will soon develop a knack after some practice.

Look at the basic shape of the nostril area and use faint guidelines to keep the drawing in proportion. Cats and small pets have small V-shaped noses that can be a lot easier to draw, but watch how you

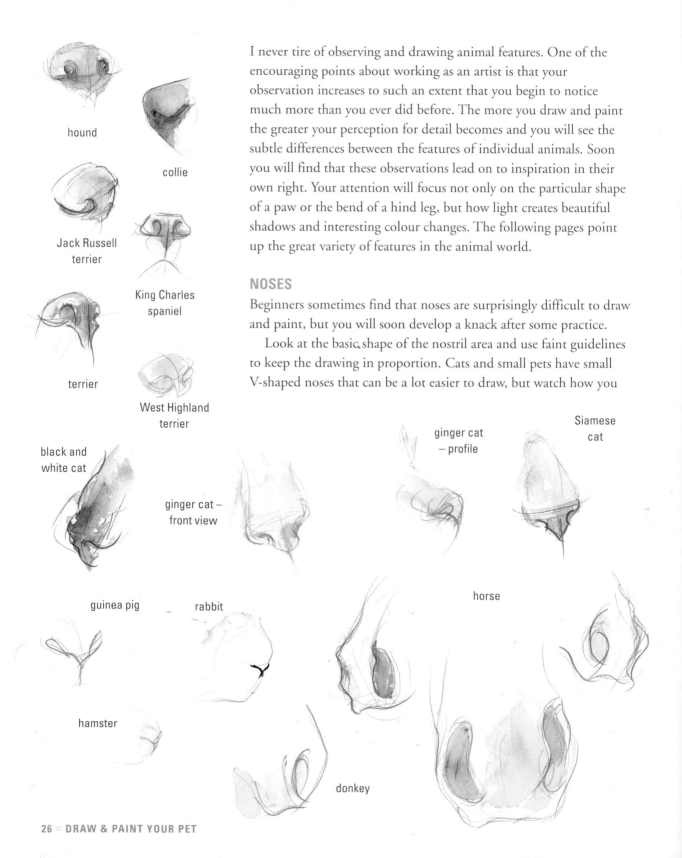

hound

collie

Jack Russell
terrier

King Charles
spaniel

terrier

West Highland
terrier

black and
white cat

ginger cat –
front view

ginger cat
– profile

Siamese
cat

guinea pig

rabbit

horse

hamster

donkey

paint in the nostrils, because you want to avoid a pig-like appearance. Dogs and horses have quite different noses, of course, and you will see from the examples I have drawn, say, of dogs that while their noses are spherical they are squared up around the nostrils. When blocking in the nose with colour vary the intensity of pigment so that you have a lighter black around the very black nostrils. Horse and pony nostrils are tear shaped, but, when painting them, be watchful that you do not apply the dark tones too heavily.

PAWS AND FEET

Paws are easier to approach if you start by enclosing them within a circular shape. You can see from my examples of dog paws that they not only differ in size, but also that the coat plays a big part. When it comes to the large furry variety, again use a circular shape, sketch in the long strands of fur and have them fall through the circle.

Cat paws are easily encompassed within a basic circular shape. Study the pads underneath and draw these using little oval shapes. Make sure that the division of the claws is properly placed as they have variable widths on the same paw. A rabbit's foot can be approached with the circular shape drawn first.

Small animals' feet are more complicated and if you look at them you will notice that they are mostly made up of lines with little oval shapes for each 'toe'.

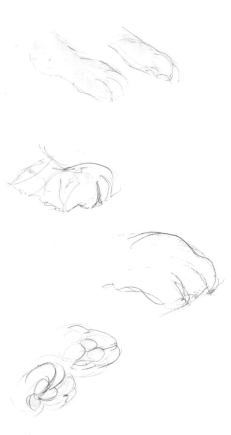

cat paws

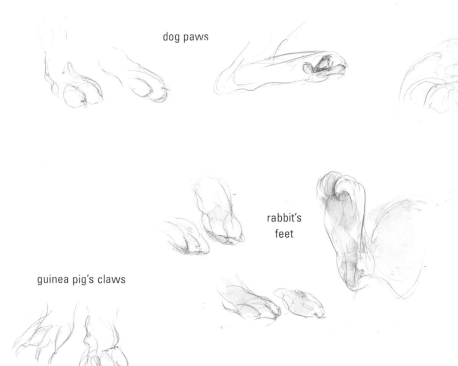

dog paws

Old English sheepdog's paw

guinea pig's claws

rabbit's feet

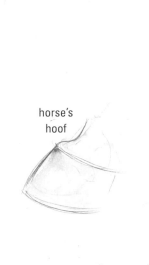

horse's hoof

EYES

Eyes contain life and express emotion and I recommend that you spend an allocated time drawing them exclusively. Animals' eyes are mostly round, except for those of the Siamese cat, whose eyes are markedly oval and slanted.

There is also much to notice as regards light and shade in any eye, and you will find an amazing mixture of colours when you really study eyes. Watch how the shadows are cast when the light is falling at different angles. Very often there is a shadow cast at the top of the eye that almost blots out the top part of the pupil.

Dogs' eyes are orangey and round, and horses' eyes are very large and protrude, giving them wide-angle vision. Cats' eyes tend to be a pale green or orangey yellow, with a very fine green rim around the pupil.

When blocking in the pupil with colour, vary the colour intensity rather than making it a black mass.

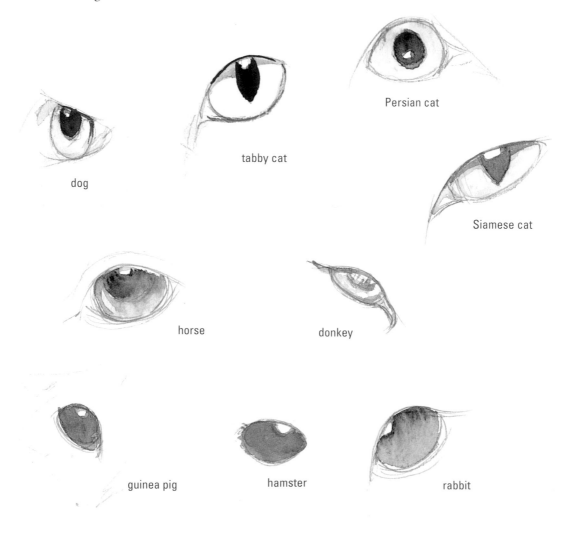

dog

tabby cat

Persian cat

Siamese cat

horse

donkey

guinea pig

hamster

rabbit

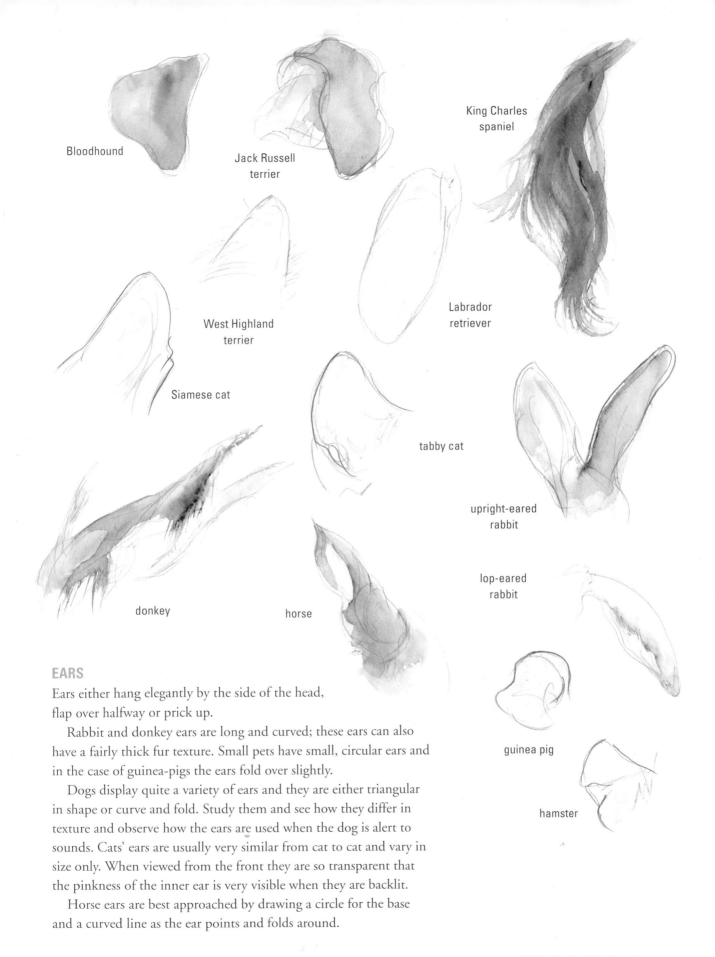

Bloodhound

Jack Russell
terrier

King Charles
spaniel

West Highland
terrier

Labrador
retriever

Siamese cat

tabby cat

upright-eared
rabbit

lop-eared
rabbit

donkey

horse

guinea pig

hamster

EARS

Ears either hang elegantly by the side of the head,
flap over halfway or prick up.

Rabbit and donkey ears are long and curved; these ears can also
have a fairly thick fur texture. Small pets have small, circular ears and
in the case of guinea-pigs the ears fold over slightly.

Dogs display quite a variety of ears and they are either triangular
in shape or curve and fold. Study them and see how they differ in
texture and observe how the ears are used when the dog is alert to
sounds. Cats' ears are usually very similar from cat to cat and vary in
size only. When viewed from the front they are so transparent that
the pinkness of the inner ear is very visible when they are backlit.

Horse ears are best approached by drawing a circle for the base
and a curved line as the ear points and folds around.

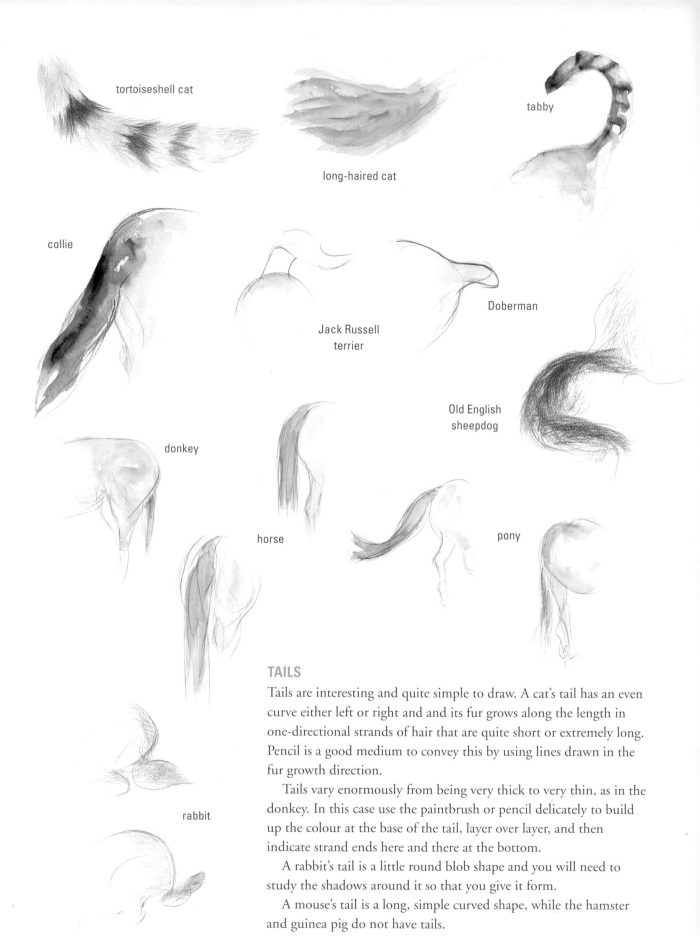

tortoiseshell cat

long-haired cat

tabby

collie

Jack Russell
terrier

Doberman

Old English
sheepdog

donkey

horse

pony

rabbit

TAILS

Tails are interesting and quite simple to draw. A cat's tail has an even curve either left or right and and its fur grows along the length in one-directional strands of hair that are quite short or extremely long. Pencil is a good medium to convey this by using lines drawn in the fur growth direction.

Tails vary enormously from being very thick to very thin, as in the donkey. In this case use the paintbrush or pencil delicately to build up the colour at the base of the tail, layer over layer, and then indicate strand ends here and there at the bottom.

A rabbit's tail is a little round blob shape and you will need to study the shadows around it so that you give it form.

A mouse's tail is a long, simple curved shape, while the hamster and guinea pig do not have tails.

FUR

I think the best way to approach drawing and painting fur is to take a feature first of all, or a small section of the body with the markings on it and just work on this area. Remember that the light shining on fur can reflect and show up many other colours that are not immediately obvious. In shadow there is always a colour change and the best way to start is to work on the darker tones first of all.

With coloured pencil work you can produce an extremely detailed result for fur strands and portray the thickness of fur by the process of applying layers of colour. Work the pencil over and over, cross-hatching where you need more density and indicate a few individual strand ends as a finishing touch.

When painting fur apply the paint well diluted and work wet-on-dry first. I prefer to use a fine size 00 brush to paint in the markings, making sure the paint is watery – this makes painting a fine line easy.

long fur

short fur

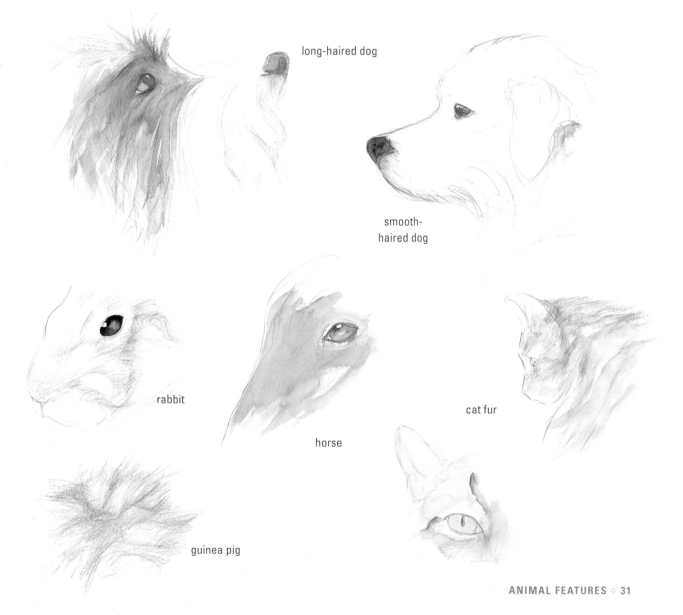

long-haired dog

smooth-haired dog

rabbit

horse

cat fur

guinea pig

Cats exert an incredibly calming influence and it is little wonder to me that their company is recommended by the medical profession as an antidote for those who suffer from high blood pressure. Over the years I have enjoyed sharing my life with six cats – plus two litters of kittens – and, while it has proved to be hazardous on some occasions, mostly it has been a real joy. I think you need to live with a cat, and preferably more than one, to truly understand a cat's nature. It is only by watching a cat grow from kitten to adulthood that you start to realize that these are among the most spiritual of animals. My cats have contributed an enormous amount of pleasure to my life and a cat is a pet that I will probably never be without.

As an artist I never tire of just observing cats. They seem to have an ability to relax – no matter what position – in a way that truly describes the definition of the word. Whether it be taking a nap or lying in the shade on a hot summer's afternoon, cats truly know how to place their bodies in the most wonderful positions of comfort. It is as well to capture these poses while you have the chance.

ROSIE LYING ON HER BACK
This tabby cat is lying in a fairly intricate pose. All the dark tones were painted first, then the various colours in her fur built up wet-on-dry. The black stripes on Rosie's tummy were painted wet-on-wet; just touching the brush down onto the paper created an authentic-looking marking!

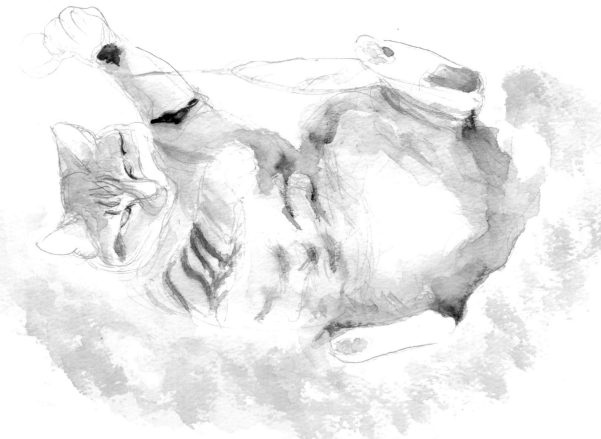

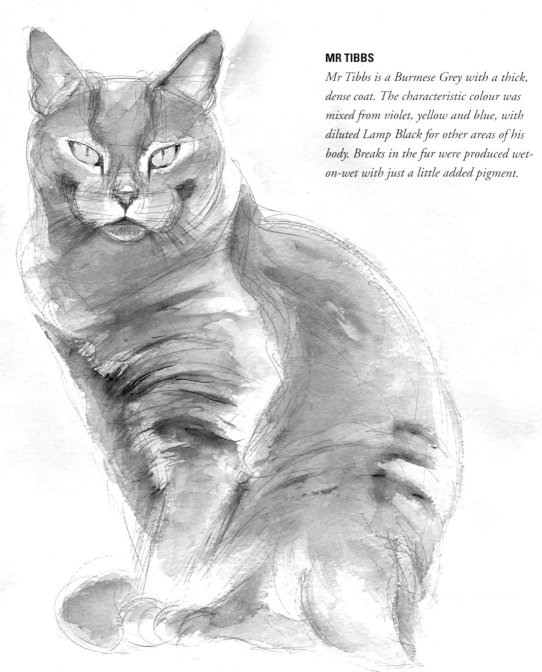

Mr Tibbs is a Burmese Grey with a thick, dense coat. The characteristic colour was mixed from violet, yellow and blue, with diluted Lamp Black for other areas of his body. Breaks in the fur were produced wet-on-wet with just a little added pigment.

When drawing and painting cats, or any animal, the main problem for a beginner is to become familiar with the basic shapes. To overcome this spend time with your cat, watch it closely and make sketches and notes on its pose when it is just lolling about or asleep, either indoors or outside in the garden. Plan out the various shapes of the body, head, features and limbs in relation to each other in the different poses the animal takes up.

Conversely, in their moments of extreme wakefulness cats are the most inquisitive of animals and are likely to dart about rapidly and quite unexpectedly. If they have fixed their attention, say, on chasing a fly, they do it with the fullest concentration and nothing will distract them. This is the time when you will have to make quick

outline sketches to record their shapes in movement. It is also an ideal opportunity to study their anatomy more closely, which is always a help in drawing. For example, watch how a cat jumps up using its hind legs and you will see why the hind legs are structured the way they are. They allow leverage and extension and are much longer than the front legs. Also watch how a cat uses its tail for balance and as a method of signalling its disposition and intentions.

Once you have mastered sketching the basic outlines of limbs and features in particular poses, you can look more carefully at how you are going to create the fur texture. A cat's coat can contain a wealth of different colours. Build these up gradually to achieve the correct variations in markings and tone to give the impression of fur thickness. Aim to create the appearance that every hair has been drawn without actually doing so.

ROSIE

Rosie's eyes and tabby markings on her face are very endearing and she has quite a wise look about her, as if she has a story to tell! The black markings on her forehead were applied wet-on-dry. Where the sun catches the side of her face, however, the markings from her eyes were worked wet-on-wet.

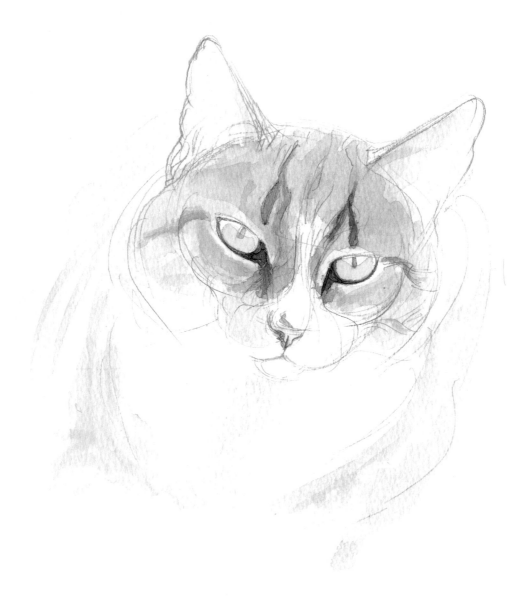

GINGER SAM

This is a finely worked painting, especially in the eye detail, which was painted first with Lamp Black and Naples Yellow. For the pink inner eye area a very diluted Alizarin Crimson was mixed with Yellow Ochre. Dark ginger stripes for Sam's thick fur were mixed from Cadmium Orange and Burnt Sienna.

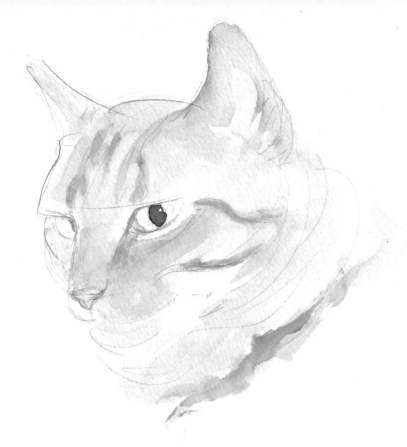

CHANEL

This beautiful little cat is in the process of her laundering. I particularly like this pose because it is unusual and, although Chanel's face is not visible, her paws and tail are prominently seen. I think it is a very appealing study. Her fur was painted wet-on-dry, letting each tone dry before applying the next layer.

RAMBO THE TABBY

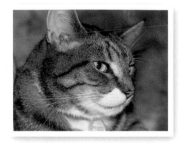

My tabby cat Rambo has been a tireless model for me over the years. I have made sketchbook notes, but also taken good sharp close-up photographs. Painting from a photograph, of course, gives you time to study detail without worrying about the cat moving. It also allows time to develop the skill of building up the fur texture with watercolour pencil or the impression of fur with a paintbrush.

MATERIALS

300 gsm (140 lb) watercolour paper, cold pressed

HB pencil

Putty eraser

Watercolour brushes:
no. 11
sizes 00 and 000

WATERCOLOUR PAINTS

Burnt Sienna

Raw Sienna

Yellow Ochre

Cadmium Yellow

Alizarin Crimson

Lamp Black

Titanium White

Burnt Umber

Sap Green

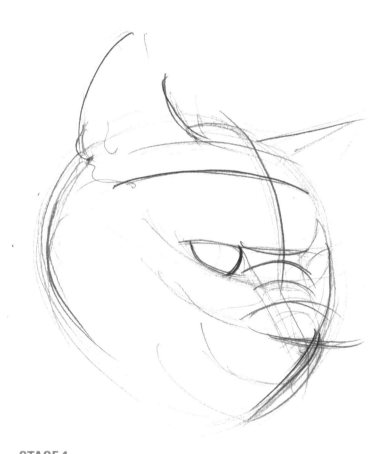

STAGE 1

I drew a circle as a first step for this painting. A cat's head appears to be made up of a series of circles and curves. There is no need to put in detail at this stage – just laying down the basic structure is all that is important. Keep an eye on how one facial feature relates to another. You will find it helpful if you sketch in guidelines within the main circle, as I have.

Study your cat's head and notice how the bone structure is formed. For example, the bridge of the nose is quite rounded and raised and the cheekbones protrude markedly.

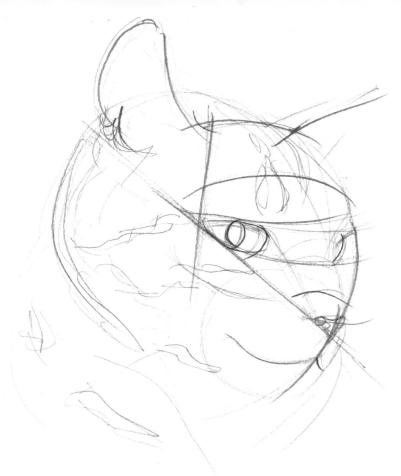

Notice how the edge of the ear falls in line with the edge of the right eye. A diagonal line is a useful guide for you to see how the other side of the ear falls in line with the nostrils. I drew in another pencil guideline to line up the ears across the top of the head. Notice how the forehead slopes flatly down towards the eyes. I kept my pencil lines light so that they could be easily erased before I began painting.

Then I drew the cat's markings and nose detail. I made sure that I reproduced the angle of the nose and the curvature of the eyes accurately. Remember the eyes are the most important feature; they capture the character and soul of the animal.

STAGE 3

Using a no. 11 brush, I painted the forehead area with some Yellow Ochre, and then below the right ear. I worked the brush in the direction of the fur growth and spread the paint evenly to avoid hard edges.

I allowed the first layer to dry and then applied the same amount of Yellow Ochre for another coat. Mistakes can be corrected in watercolour, but only if you can do so speedily before the paint begins to dry.

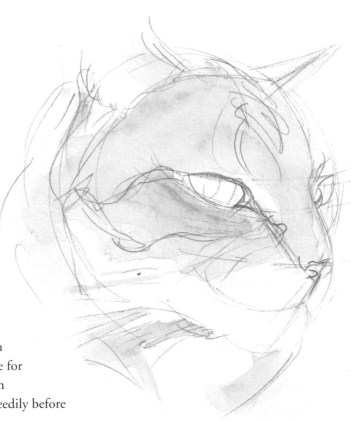

STAGE 4

For this stage I used Raw Sienna to emphasize the darker, 'warmer' areas of yellow in the fur. For the more reddish areas I mixed up a little Burnt Sienna and Yellow Ochre together.

You can build up an impression of the cat's whiskers at this stage. Using a size 00 brush, I lightly painted in Raw Sienna to delineate the whisker line. If you find these lines are overdone you can sponge out with a tissue. Alternatively you can use Chinese White and a fine brush.

For the larger areas of Raw Sienna I used a no. 11 brush.

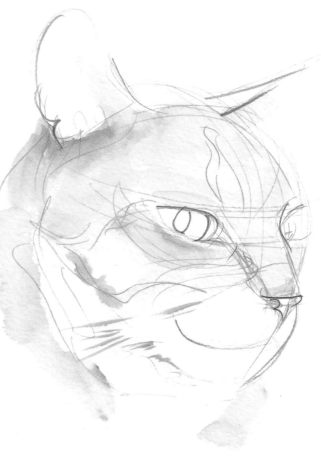

STAGE 5

I applied a small amount of Burnt Umber with the size 00 brush, working in the direction of the fur growth. I used the tip of the brush to ease the colour towards the edge of the fur line around the base of the right ear. This gave a hard edge just where I needed it. I allowed it to dry.

I applied the same colour again as a second coat, but only in the areas of darker brown fur. Then I started to use a wet-on-wet technique by applying paint onto a wet surface of colour. This looks very effective as the colours bleed.

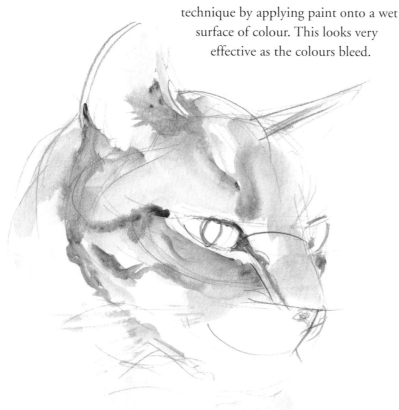

TIPS

o When you start to paint do not rush the process.

o Watercolour paint in tubes is concentrated, so you need to use only a little on the tip of your brush.

o Keep the amount of water you use to a minimum. If you have too much water on your brush, just shake some of it off.

o Have a tissue at hand to mop up any excess water.

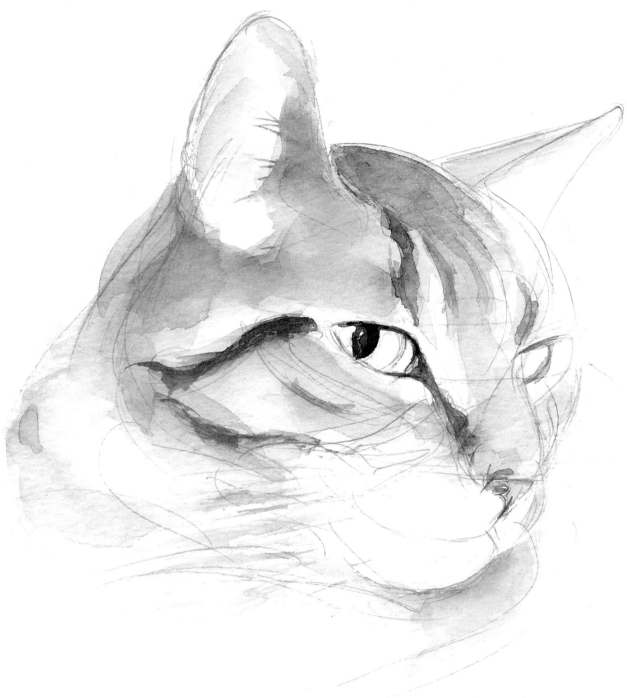

STAGE 6

With a fine size 00 brush I painted in the pupils of the cat's eyes with Lamp Black. I left a little area of white paper for the glint of the eye, but you could also use a dot of Titanium White. I applied two coats of black to the right pupil, but when putting down the second coat I covered only three-quarters of the pupil area. I allowed this to dry.

I used Cadmium Yellow for the coloured part of the eyes and Sap Green for the rim. For the nostrils I mixed Yellow Ochre and Alizarin Crimson with a little Titanium White.

MAXI THE BLACK AND WHITE CAT

MATERIALS

300 gsm (140 lb)
watercolour paper, cold
pressed

HB pencil

Putty eraser

Watercolour brushes:
no. 8 round
sizes 00 and 000

WATERCOLOUR PAINTS

Lamp Black

Burnt Sienna

French
Ultramarine

Alizarin Crimson

Like most cats, Maxi likes to sit quietly keeping a watchful eye on the wildlife of the garden around her. She is always enthusiastic about life in general and this active interest can be quite contagious to others. I really enjoyed painting this picture of Maxi because of its beautifully simple outline. Even as a line drawing on its own it makes a pleasing composition. Although Maxi is a black and white cat there are many other colours to be seen in her fur and watercolour is the ideal medium to use to emphasize these. The sun reflecting on her coat has brought out the reddish brown highlights of her fur.

STAGE 1

As you can see, for Maxi's head I worked with a circle as a basic shape. I placed the ears and nose only lightly as I did not want to put in too much detail at this stage. The rest of the cat's body is made up of curves. Just making sketches of this pose alone will help improve your skill in drawing a 'loose' picture.

STAGE 2

I started adding in a little more detail. Obviously there is not too much that is defined at this stage, but adding the little lines for Maxi's eye and nose brought the drawing alive. I lightly drew in the details of the paws and while I was sketching I constantly kept in mind what colour I would paint different areas.

STAGE 3

With a no. 8 round brush, I applied Lamp Black to a large area of Maxi, and allowed this to dry. I then painted another layer of Lamp Black where she has very dark tones in her fur and allowed this to dry. I left some areas blank so that I could paint in the French Ultramarine and Burnt Sienna mix. The sun reflecting on her coat made me realize just how much colour there is in a 'black' coat.

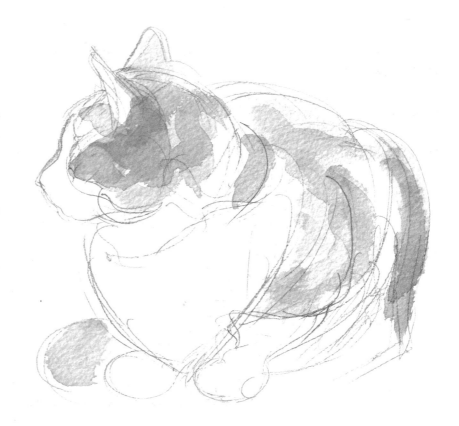

STAGE 4

Using equal amounts of French Ultramarine and Burnt Sienna, I painted a light watery mix to the coloured areas of Maxi's coat. I allowed this to dry and, using the same mix, I strengthened this colour. I decided on a loose 'sketchy' painting, so I have retained more pencil lines than usual at the painting stage. It is a good idea to leave out collars because they are sometimes rather garish and inhibit a natural-looking image.

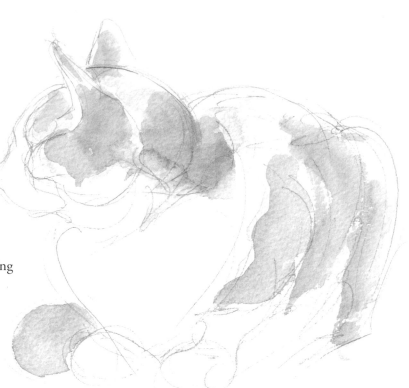

STAGE 5

I strengthened the darkest areas of Maxi's 'black' coat using a no. 8 brush and some watery Lamp Black. When painting in the dark tones it is advisable to cover more area than you see in the photograph to avoid creating an unwanted hard edge. Brushing the colour over a wide area prevents this problem, or you can use a tissue to dab up any excess moisture.

Where the strands of white fur lap over onto the dark fur I dampened the area first with a clean brush. Then I lightly touched a size 000 brush onto the paper to paint in little lines. This wet-on-wet technique creates an attractive, unlaboured effect.

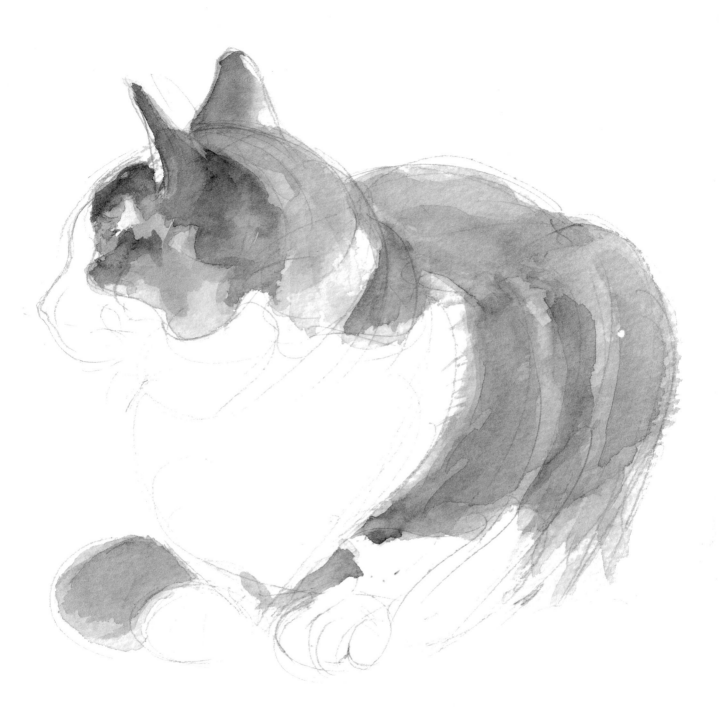

STAGE 6

I strengthened all the colours, being careful not to be too heavy handed. Where the coat appears redder I used a watery Burnt Sienna and lightly painted this into the fur. I painted the shadows on Maxi's white chest with the tip of a no. 8 brush, using a very watery Lamp Black. I touched in a little pinkness at the base of her left ear with Alizarin Crimson, again making sure that the colour was watery.

Photo: Ann-Louise Dyer

This is one of those kinds of photographs that are incredibly helpful in providing reference for the artist as well as being works of art in their own right. A cat in its everyday activities tends not to remain in a pose like this for long. Such a photo gives you the opportunity to study the animal's features closely and to practise your watercolour techniques to your heart's content!

MATERIALS

300 gsm (140 lb) watercolour paper, cold pressed

HB pencil

Putty eraser

Watercolour brushes:
no. 8
sizes 00 and 000

WATERCOLOUR PAINTS

Lamp Black

Naples Yellow

Payne's Grey

Alizarin Crimson

Chinese White

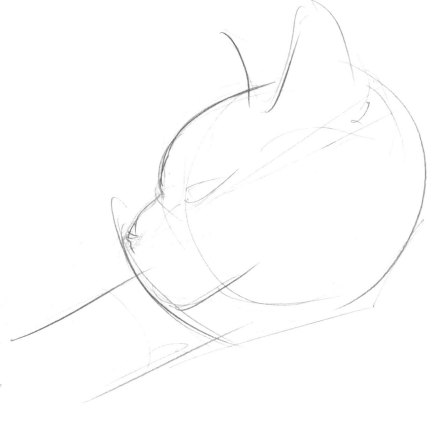

STAGE 1

I drew the general outline of the head lightly with an HB pencil. The forehead is quite sloping from this viewpoint, so I made sure I got this angle right. Notice the guideline I have drawn that runs from the nostril through to the outer edge of the ear. Laying down lines such as this will help you produce an accurate drawing and a picture that bears a good likeness to its subject.

I drew the outline of the eye shape lightly – there is no need for detail at this stage. You can also draw part of the legs as they appear in the photograph.

STAGE 2

I drew the pupil of the eye, leaving a small circle for the glint of reflected light. The white paper can serve well for this at the painting stage.

I pencilled in the dark nostril and general outline of the nose. The bridge of Mr Tibbs' nose is very rounded and overlaps the edge of the nostril area. His muzzle is quite square and deep, while the length of the nose is fairly short. Cats' faces vary quite dramatically from breed to breed and it is not until you either own a cat, or spend time drawing and painting one, that this fact becomes obvious to you.

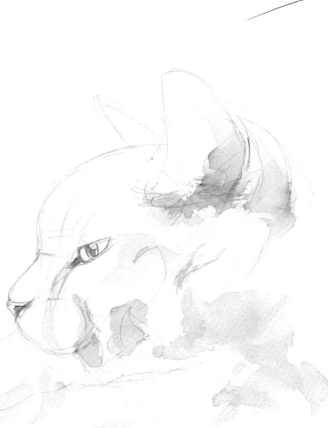

STAGE 3

Using a size 000 brush, I took up some well-diluted Lamp Black and painted in the pupil. I noted the position of the glint of the eye and left the white of the paper for this. It is important to take this stage slowly and I used just a little colour on my brush, then allowed the paint to dry.

Using a no. 8 round brush, I again took up some well-diluted Lamp Black and painted in the darker areas such as the shadows on the muzzle and the inner ear and the lines of fur pattern on the side of the face. You can use a little wet-on-wet technique at the base of the ear particularly. So, before the shadowed areas dried off, I gently brushed out this colour into individual strands of fur. If this area is already dry then either dampen it with a clean brush, or if you need a little more pigment, put some well-diluted Lamp Black onto your brush and paint in the strands you need. Just two or three is sufficient. Then allow this to dry before continuing.

STAGE 4

I continued to darken the shadowed areas and used a size 00 brush for the very dark tones around the muzzle. I continued the wet-on-wet technique used at the base of the ear for the rest of the inner ear. To strengthen these dark tones I applied a little more watery Lamp Black using a no. 8 brush. Then, with a size 00 brush, I worked in the detail of where the individual strands show more definitely in the lighter areas of fur. For the other ear I used watery Lamp Black and with a size 00 brush painted just a hint of hairs of fur growth.

For the pink hue of the inner ear I used a watery mix of Alizarin Crimson and Yellow Ochre, letting this dry before building up with the same amount of pigment again.

I painted more colour into the eye at this stage too. I used a watery Payne's Grey and painted this in with a size 000 brush. I also darkened the pupil with more Lamp Black.

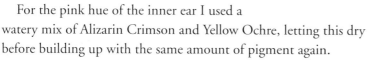

Cats' eyes are magnificent in their intricacy of colour formation. When viewed from this angle they reflect other colours and in this case there is a touch of blue reflecting from the pupil.

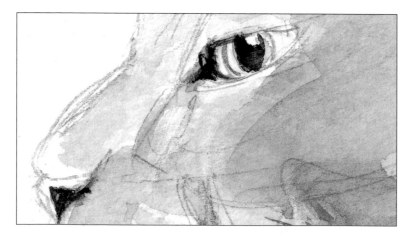

STAGE 5

I washed my brush well in clean water and painted in a hint of Naples Yellow for the rest of the eye colour. Some areas are denser in colour than others, so I mixed up Payne's Grey with Lamp Black for the next layer applied to the pupil.

Wet-on-wet technique was useful to create the impression of whiskers. I applied diluted Lamp Black on Mr Tibbs's muzzle with a no. 8 brush, then used a size 00 brush for the whiskers. If your paint mixture is too dry and the fine black lines are too severe, take a damp no. 8 brush and gently brush into the whiskers before they dry. You may also wish to paint in the whiskers growing above the eyes.

I continued to apply a mixture of Payne's Grey and Lamp Black to the face and what could be seen of the legs until there was a sufficient build-up of colour. Before this dried I used a size 00 brush, dipped in Lamp Black, to paint in the folds in the fur. This merged into the soft lines needed to look effective.

I used a little Chinese White to highlight certain areas such as the front of the muzzle and forehead. You could also knock the harshness of other areas back with a little touch of white, but easy does it as this can be easily overdone.

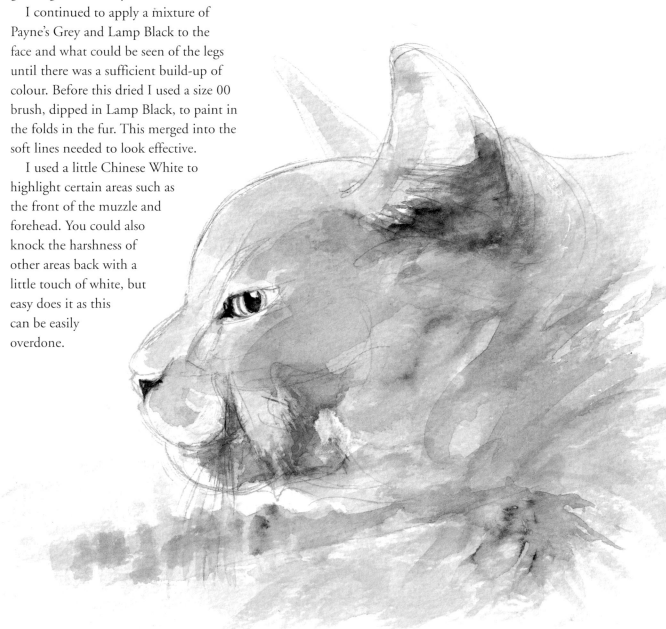

DOGS

Dogs obviously vary much more so than cats in breed and type, but they too are beautiful creatures that are fantastically loyal. Like most pets they offer an unconditional love and every time they greet you they express this love with great enthusiasm. You are never left in any doubt as to how your relationship stands at any one time. A dog is man's best friend – never a truer word spoken.

I love the variety found in dogs, whether small or large. I have drawn and painted many breeds and to see the form of a dog appear on paper or canvas is always a joy. I grew up with dogs as pets as a child, as my parents owned an Irish wolfhound and a Jack Russell.

GEORGE

George is a lovely strong-looking golden retriever. The pose is so typical of the gentle character of the breed and it was this that I tried to capture while making this painting of George. I worked wet-on-dry, overlaying transparent washes of Yellow Ochre, Burnt Sienna and Cadmium Orange.

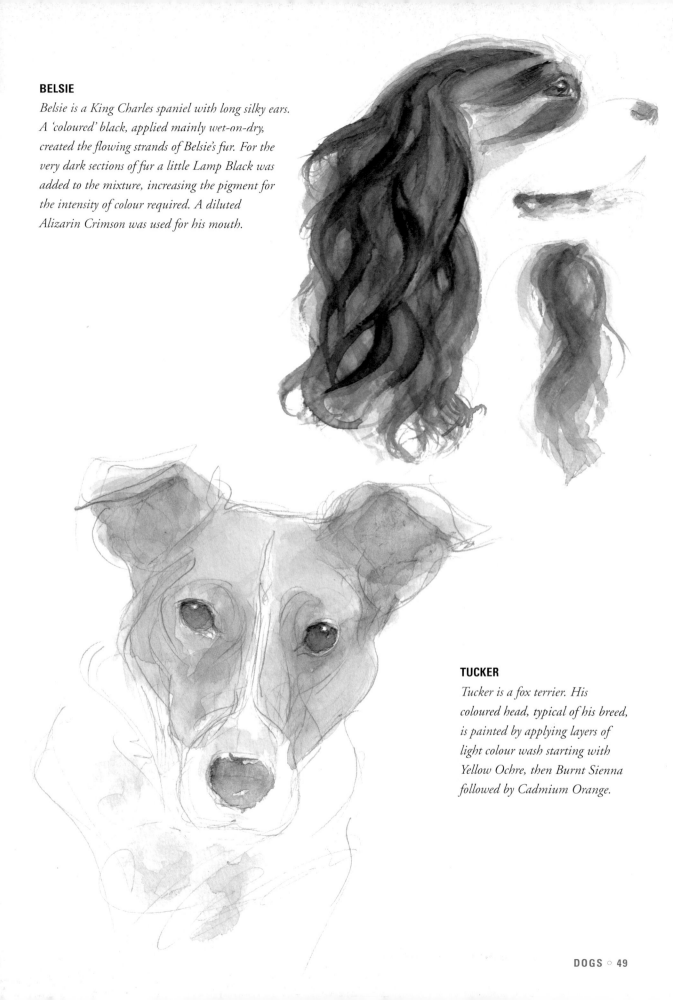

BELSIE

Belsie is a King Charles spaniel with long silky ears. A 'coloured' black, applied mainly wet-on-dry, created the flowing strands of Belsie's fur. For the very dark sections of fur a little Lamp Black was added to the mixture, increasing the pigment for the intensity of colour required. A diluted Alizarin Crimson was used for his mouth.

TUCKER

Tucker is a fox terrier. His coloured head, typical of his breed, is painted by applying layers of light colour wash starting with Yellow Ochre, then Burnt Sienna followed by Cadmium Orange.

DENVER

Denver is an extremely well-bred Border collie and I particularly enjoyed painting him in this pose. He has a good, solid build and a thick, shiny coat, painted with overlaid washes. Like most Border collies, Denver has a fine temperament and is extremely loyal. I think this picture of him depicts this quality well.

In later years we had a corgi who never let his size deter him from any form of attack when the circumstances required. The point that strikes me in my dealings with small dogs is just how courageous they are. Our family corgi was almost a legend in our neighbourhood in that he had the bark and fighting spirit of a dog three times his size. Yet, when amongst friends and showered with love, he was the sweetest, most lovable pet ever put on this earth! The task of the artist is to convey the individual character of each dog that is offered as a subject.

Since there are so many types of dog each animal presents different problems for the artist. If you are drawing or painting a specific breed it is useful to study the anatomy of that breed to help you understand the bone and muscle structure of the individual dog.

The particular point I would like to highlight when drawing and painting dogs, however, is learning how to bring the overall form back to its simplest shape (see 'Basic Sketching' on page 14). Look at your dog from different viewpoints. Is the head square or cone shaped, for instance? What shape are the dog's muzzle, nose and ears?

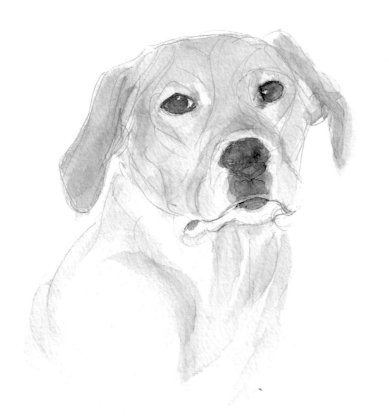

GEORGE

George, a golden Labrador retriever, is a proud and handsome fellow. Yellow Ochre was used for the light honey tones of his coat, with Burnt Sienna for the warmer areas around his ears. Areas of shadow around his eyes were created by drawing out the Lamp Black of the pupils before it dried. This created a dark tone for the basic eye colour of Burnt Sienna applied on top.

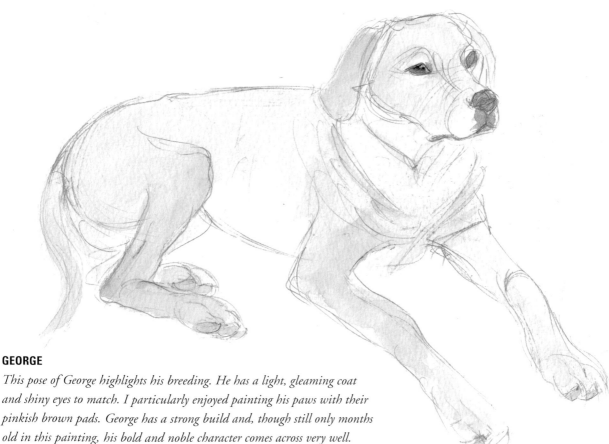

GEORGE

This pose of George highlights his breeding. He has a light, gleaming coat and shiny eyes to match. I particularly enjoyed painting his paws with their pinkish brown pads. George has a strong build and, though still only months old in this painting, his bold and noble character comes across very well.

Getting the relative proportions correct is also important. Use the head as a measuring unit and see how many heads make up the whole body length and height.

As regards movement, watch your subject and see how his front legs act in relation to his hind legs. Watch how he holds his head when he is intent on something and again make as many sketches as you can. Look at the colours within his fur. If he is a black dog just check to see if the fur is truly black. Perhaps a 'coloured' black made from two dark colours is more appropriate.

BELLA

watercolour pencil

This is another extremely well-bred dog – Bella, an Italian spinone – who enjoys the country life. I decided to draw Bella's portrait in watercolour pencil as well as paints. This kind of drawing is a good exercise in precision and detail. The pencils were always kept extremely sharp and applied lightly.

BELLA

Watercolour painting requires immense concentration, especially for a dog like 'beautiful Bella' with her long curly locks! I tried this painting both wet-on-wet and wet-on-dry, and opted for the latter. Transparent washes of colour were applied with just a little more pigment added each time until the correct intensity of colour was reached.

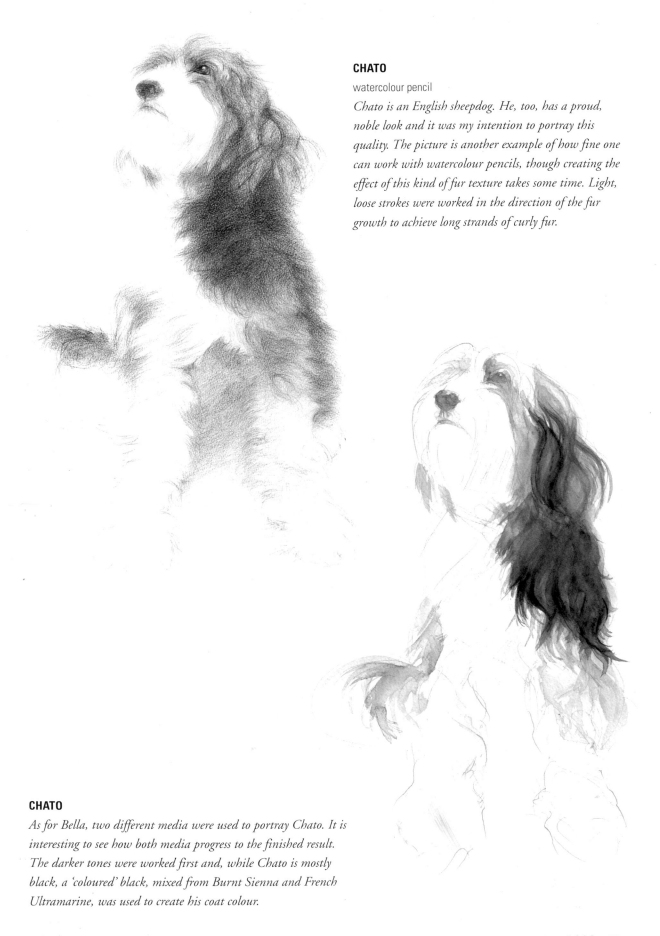

CHATO

watercolour pencil

Chato is an English sheepdog. He, too, has a proud, noble look and it was my intention to portray this quality. The picture is another example of how fine one can work with watercolour pencils, though creating the effect of this kind of fur texture takes some time. Light, loose strokes were worked in the direction of the fur growth to achieve long strands of curly fur.

CHATO

As for Bella, two different media were used to portray Chato. It is interesting to see how both media progress to the finished result. The darker tones were worked first and, while Chato is mostly black, a 'coloured' black, mixed from Burnt Sienna and French Ultramarine, was used to create his coat colour.

JEG THE HALF BORDER COLLIE

This is a very appealing picture of Jeg and the position of his ears makes them look quite hat-like. I chose this pose not only because of its appeal, but also because it is quite straightforward and involves forming a basic structure at the beginning. Painting a black and white dog provides an interesting project in using black or getting acquainted with mixing a 'coloured' black or 'dark'.

MATERIALS

300 gsm (140 lb) watercolour paper, cold pressed

HB pencil

Putty eraser

Watercolour brushes:
no. 11
size 000

WATERCOLOUR PAINTS

Lamp Black

French Ultramarine

Burnt Sienna

Sepia

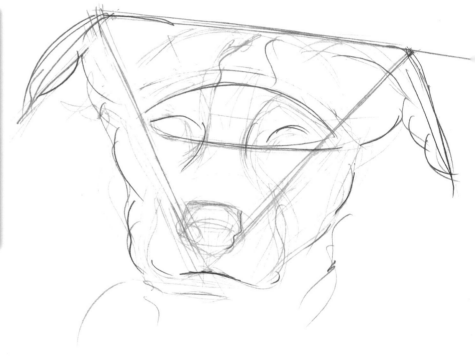

STAGE 1

Using an HB pencil I lightly drew the basic shapes. From the guidelines I have drawn in you can see that the features can be placed within a triangle. This helped me to line up the features accurately. There was no need to become involved with any detail at this early stage, so I concentrated on the basic outline.

It is very important to put the basic foundation down accurately because it allows you to progress in the drawing. Always keep a check on how one feature relates to another. If you use an eye, say, as a measuring unit, you can measure how many eye widths go into the bridge of the nose to confirm the proportions. When you have the initial elements correctly placed you will find that the rest of the drawing becomes straightforward.

STAGE 2

Now I could pencil in the pupils
of the eyes and other
characteristic features.
Jeg has quite a generous
white marking in
between his eyes that adds a
dramatic look to his appearance. The top
of his head along to the middle of his ears
appears quite flat, which I like.

It is important to make sure you pencil
in the detail for all your painting, so that
you know what step you can take next.
I have discovered that even when
painting spontaneously, if I have a
precise knowledge about the detail,
then the picture works out well.

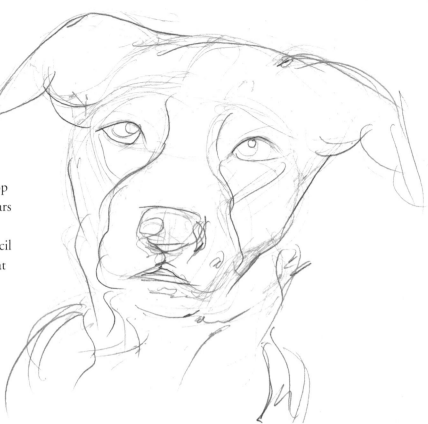

STAGE 3

With a size 000 brush
and a little Lamp Black,
I painted in the pupils
of the eyes. I left a small
circle of paper showing
through for the
reflected glint. As Jeg's
eye is in shadow I used the
brush to ease out the watery Lamp
Black into the corner of his eye, then let
this layer of paint dry.

Then with a no. 11 round brush I
again used Lamp Black, but kept it very
watery, to paint in Jeg's black fur. For the
darkness around the top of each eye I
applied a stronger amount of pigment. I
left two small areas above the eyes where
the detail in the black fur is rather
difficult to see.

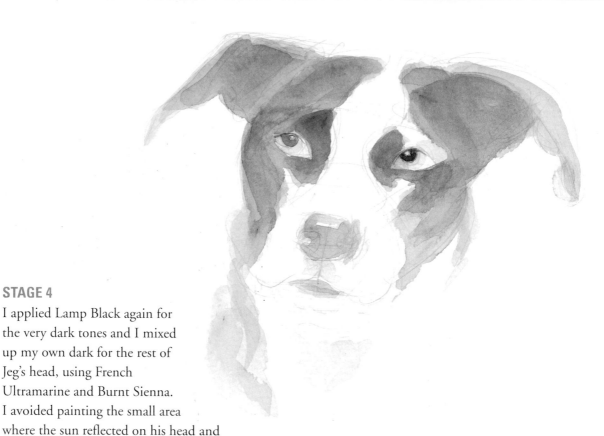

STAGE 4

I applied Lamp Black again for
the very dark tones and I mixed
up my own dark for the rest of
Jeg's head, using French
Ultramarine and Burnt Sienna.
I avoided painting the small area
where the sun reflected on his head and
left the white paper showing through. If you
find it tricky to reserve areas of white paper to capture
the effects of sunlight you can use a little Chinese White and lightly
paint a line, but remember to keep it well diluted.

I also painted the base colour for the eyes. This was a watery Burnt
Sienna, which I applied with a clean
no. 11 round brush.

For the shadows under Jeg's chin I used a watery mix of Sepia and
very lightly touched this onto the paper with the tip of a no. 11
brush.

Jeg has a healthy black wet
nose! Watery layers of
paint are used to build up
the shape of the nose and
to bleed into the
surrounding areas as
shadow, leaving a lighter
part on top to reflect the
light. A hint of colour is
used to portray the soft
folds of skin and fur
around her mouth.

TIPS

o Keep a watchful eye on
your paint after you have
applied it to avoid runs that
may create unsightly hard
edges when dry.

o Always have a tissue or
small sponge handy to mop
up any excess moisture.

o Do not rush your
painting even when
tempted by enthusiasm.

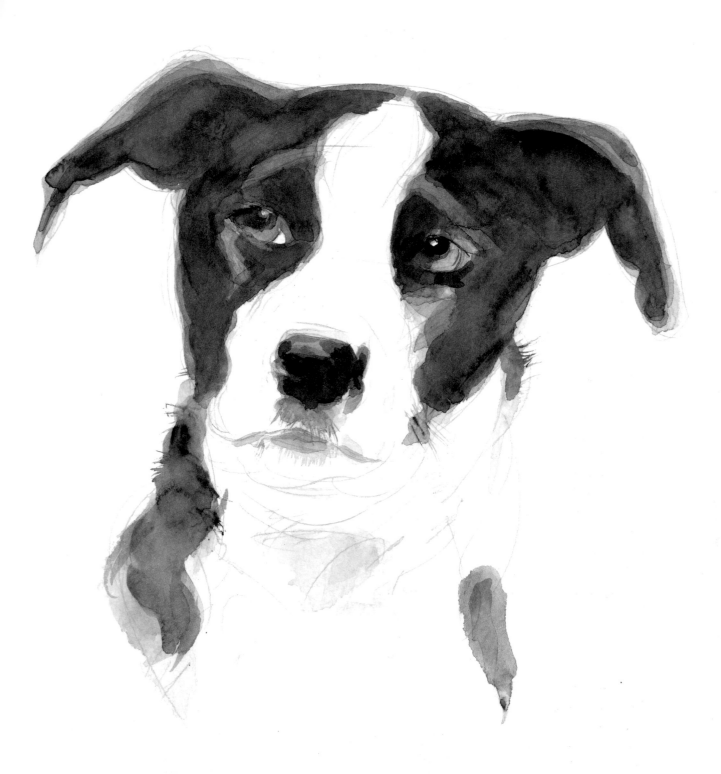

STAGE 5

Washes of the French Ultramarine and Burnt Sienna mixture made up the lighter areas of Jeg's coat. For the very dark areas I used a stronger pigment of Lamp Black and applied this with the tip of a no. 11 brush, still keeping the paint well diluted to avoid the possibility of any unwanted daubs.

 I darkened the eye colour with Sepia and let this dry. The final touch was to strengthen the black colour in the pupils with a fine size 000 brush.

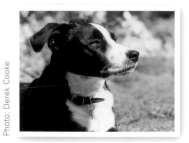
JEG IN PROFILE

Jeg is fortunate enough to have a master who is a professional photographer and here Derek Cooke has captured him just before he was about to leap off somewhere – quite a task. He was just a puppy in this photograph. Jeg's head in profile presents quite a different shape to the artist from the angle shown in the demonstration on pages 54–57. Notice, too, how the light has caught his fur. I have used both watercolour pencils and paints to show how choice of medium can be used to depict a different quality for the same pose.

JEG

watercolour pencil

In this study Jeg is portrayed in a fairly tight style. Colour can be built up with watercolour pencils to the point where it almost is like fur on the paper! I used Ivory Black for the basic dark areas and where the sun caught his coat I worked Ultramarine Blue and Burnt Sienna, one applied over the other.

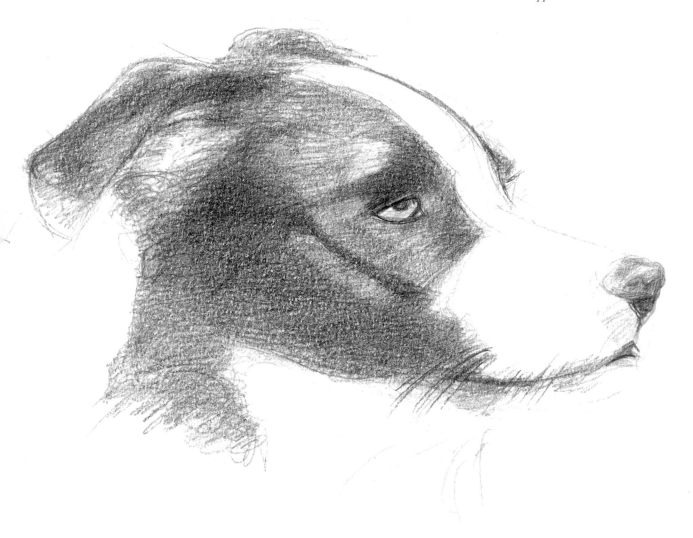

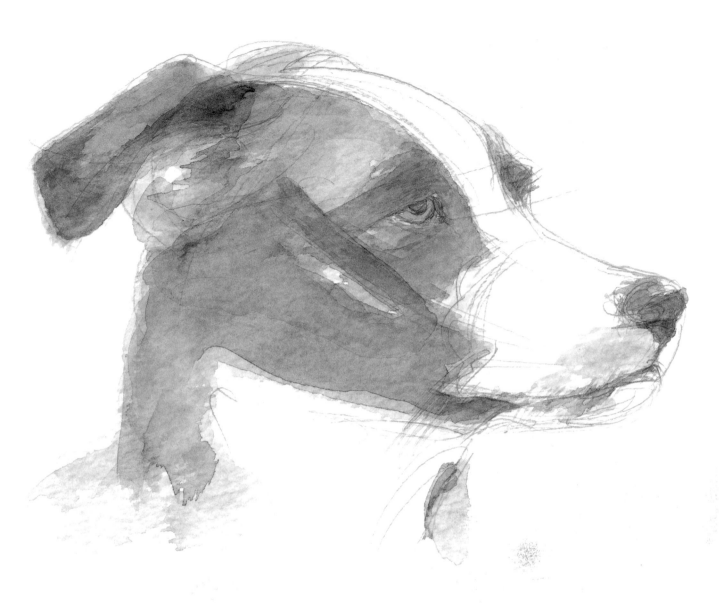

JEG

I really enjoyed painting this picture of Jeg. Watercolour allows a far looser style than watercolour pencils and, although the precision in the fur and other details is more impressionistic, it portrays his character well. As in the demonstration I applied a watery Lamp Black for the most glossy areas of fur and mixed a 'coloured' black for the other dark areas of his coat. I prefer not to use white if I can help it, but like either to allow the paper to be untouched by paint in areas or to use a transparent wash.

CHIPPY THE JACK RUSSELL

I spend many pleasurable times with Chippy and often sketch him from life, which is entertaining and can be rather unpredictable. I have also taken many photographs of him and I thought this one in particular portrayed his unique personality extremely well. It was taken with a good-quality camera and lens and the result serves as an excellent reference when making a study for a painting.

MATERIALS

300 gsm (140 lb) watercolour paper, cold pressed

HB pencil

Putty eraser

Watercolour brushes:
no. 8
size 00

WATERCOLOUR PAINTS

Lamp Black

Alizarin Crimson

Yellow Ochre

Burnt Umber

Burnt Sienna

French Ultramarine

Paynes's Grey

STAGE 1

First I lightly drew the basic shape of Chippy's head. The guidelines highlighted the shape and would serve as a tool to keep the picture in proportion. It is important always to keep an eye on how each feature relates to another. I drew a line from the outside edge of the eye to the edge of the nose to help place the features correctly.

There is no need to put in any detail at this stage; just concentrate on familiarizing yourself with the overall shape of the animal. Drawing the shape of his ear, for instance, could be broken down in three stages, as you will see from the sketch I have done.

STAGE 2

I now started to put in detail. I always start with the eyes, so I drew in the pupil, leaving a small white circle of paper for what will be the reflected glint. I also drew in the detail of the other eye, which is just about visible.

Next I put in more detail for the nose. Dogs' noses are always rounded on top and the intricate nostril area can be difficult to depict. I only needed to draw in the contour of one nostril because the rest of the effect would be produced by watercolour and the build-up of tone.

STAGE 3

I drew in Chippy's whole tongue, then indicated the tooth shapes so that I could leave paper to show through for the teeth.

After painting the pupil and outer rim of the eye with diluted Lamp Black, I drew out the colour with a fine brush, taking it to the outside corner of the eye. Before the paint dried completely I gently dabbed a slightly stronger touch of pigment down on to the pupil again.

With a no. 8 round brush I painted in the darker tones of the nose with Lamp Black and, when dry, applied another layer. Then I painted in the dark fur colouring within the browner patches on the top of Chippy's head, and around and in the ear. The shadow on the tongue was a watery mixture of Payne's Grey and Lamp Black, and I used a diluted Lamp Black for the darkness of Chippy's left eye.

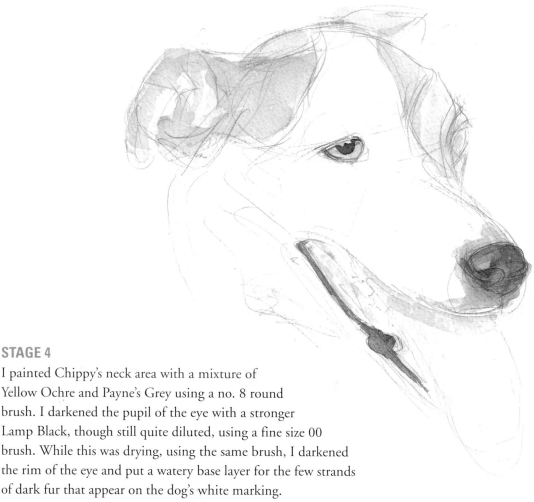

STAGE 4

I painted Chippy's neck area with a mixture of
Yellow Ochre and Payne's Grey using a no. 8 round
brush. I darkened the pupil of the eye with a stronger
Lamp Black, though still quite diluted, using a fine size 00
brush. While this was drying, using the same brush, I darkened
the rim of the eye and put a watery base layer for the few strands
of dark fur that appear on the dog's white marking.

Making sure my brush was well washed out, I applied Burnt
Umber for the rest of the eye colour. Then I added a touch of Yellow
Ochre and applied this watery colour to the yellowish areas on the
head and ears.

As the tongue is a yellowish pink I put down a base of Yellow
Ochre, with a no. 8 brush. I also painted Yellow Ochre on all the
pink areas of the mouth, working around the outline of the teeth
with the tip of the brush, and keeping the white of the paper reserved
for the teeth.

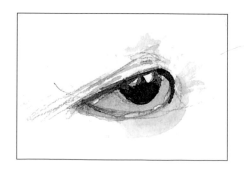

*The first layer of colour applied
around the eye is very weak. This
allows you to control the paint
more easily as it is drawn out by
brush to create a soft outline. I was
careful not to paint over the small
circle of white paper reserved for
the reflected glint.*

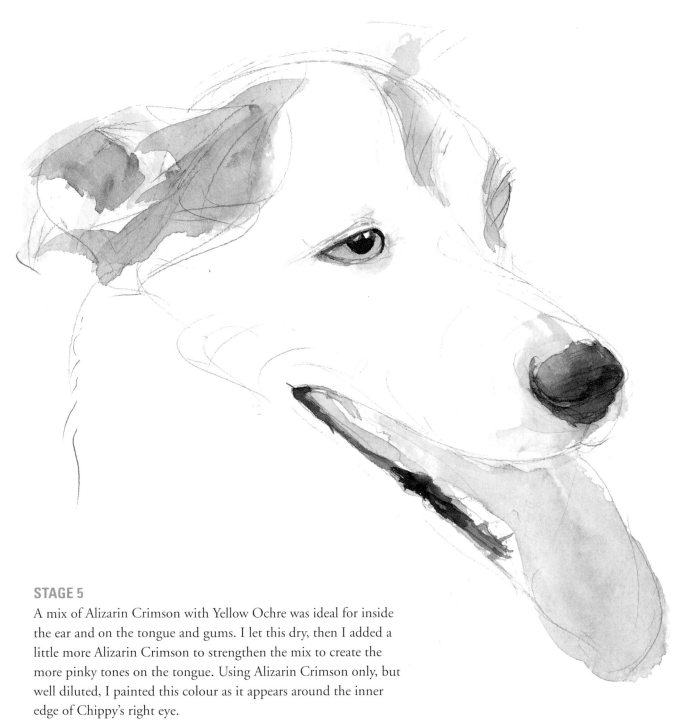

STAGE 5

A mix of Alizarin Crimson with Yellow Ochre was ideal for inside the ear and on the tongue and gums. I let this dry, then I added a little more Alizarin Crimson to strengthen the mix to create the more pinky tones on the tongue. Using Alizarin Crimson only, but well diluted, I painted this colour as it appears around the inner edge of Chippy's right eye.

When this was dry, I outlined the teeth with Yellow Ochre and Alizarin Crimson and, while this was drying, strengthened the dark tones within the ear and around it. I painted another layer of Burnt Umber on the coloured part of the eye.

For the nose I mixed Burnt Sienna and French Ultramarine and applied a couple of layers. I then pulled this colour out with the tip of a no. 8 brush onto the white fur around the nose and underneath it. Finally, I applied well-diluted Lamp Black to the darker shadows of the nose, particularly around the nostrils.

DENVER THE BORDER COLLIE

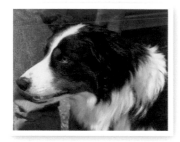

Denver is a large, playful dog and it is essential to work from a photograph if you are painting a portrait of a particularly lively animal for the first time. With experience and in time you will acquire the skills to paint a dog from life, but I recommend using photographs before you tackle that task! They also give you the chance to practise painting lovely long strands of fur, for example.

MATERIALS

300 gsm (140 lb) watercolour paper, cold pressed

HB pencil

Putty eraser

Watercolour brushes:
no. 11
sizes 00 and 000

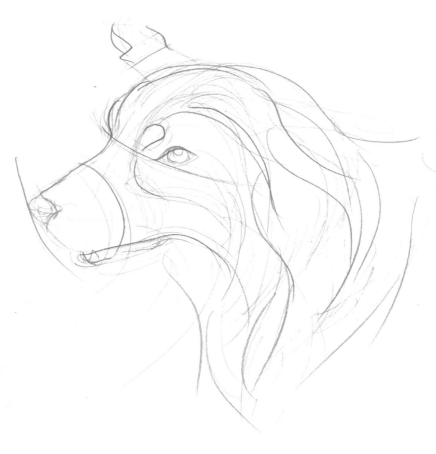

WATERCOLOUR PAINTS

Lamp Black

Burnt Sienna

French Ultramarine

Yellow Ochre

Cadmium Orange

Titanium White

Naples Yellow

STAGE 1

I lightly sketched Denver's head using constructional guidelines to help me place his features correctly. Always take a good look at the features of your subject. See how Denver's bottom jaw falls short of the upper jaw area. Notice, too, that the eye shape slants slightly, with the eyeball sitting quite visibly in the middle.

I drew the shapes of Denver's markings. His long fur tapers into a white collar on the shoulders, so I needed to roughly indicate the direction of the fur strands here. This collie's fur markings are particularly interesting, with hints of orange appearing around the eye area and I lightly pencilled in where the colour changes happen.

STAGE 2

Using a size 00 brush, I painted the outer circle and pupil of Denver's eye.

For the dense areas of Denver's fur I lightly applied Lamp Black. His coat contains a lot of blue-black and brown, so I used a 'coloured' black mixed from Burnt Sienna and French Ultramarine for the other dark areas of fur. I varied the proportions of the two colours according to how the sun reflected the light on his coat. When the first layers had dried I added more Lamp Black and the 'coloured' black, well diluted, to build up the illusion of thick fur. Then I dipped a size 000 brush into the colours to paint in the fine ends of fur that fall into the white 'collar'.

Watery Yellow Ochre formed the base for the orange markings, and just before it dried I applied a mix of Yellow Ochre, Burnt Sienna and Cadmium Orange on top.

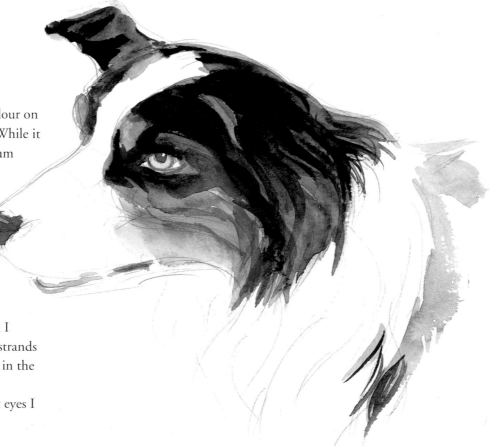

STAGE 3

I painted a third layer of colour on the darker areas of the fur. While it was still wet I added Titanium White into the diluted French Ultramarine and Burnt Sienna mix to give a natural-looking grey for the shadowed areas of white fur. I used Titanium White for the white fur. With a fine brush I painted in some individual strands from the lower dark section in the direction of the fur growth.

Finally, for Denver's light eyes I used Naples Yellow.

WAFFLE THE BORDER TERRIER

When I first met Waffle he won me over well and truly, not only by his very engaging personality, but by his appearance. He was still only a puppy when I made this portrait of him. I not only had to build up a rapport with him in a short period of time, but also had to keep him interested enough to stand still for 30 seconds before he bounded off to the next game of the day. Watercolour pencils are an ideal medium to portray his wiry fur, which is a mixture of different colours. The pencils really come into their own as you watch the fur effect gradually building up as you work, but always remember to keep them sharp for a crisp look.

MATERIALS

300 gsm (140 lb) watercolour paper, cold pressed

HB pencil

Putty eraser

Watercolour brush: size 000

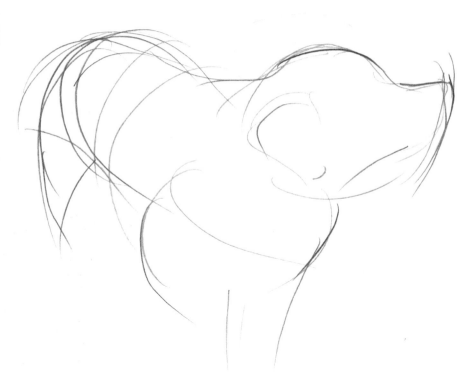

WATERCOLOUR PENCILS

Burnt Yellow Ochre

Ivory Black

Sepia

Burnt Sienna

STAGE 1

I faintly pencilled in the general outline of Waffle's head and body. The first stage of any picture deals with the basic outline and if this is done accurately from the outset the later stages will come together to produce the likeness of your subject. I was not concerned with detail at this stage, but just with making sure I was lining up the features properly and getting the proportions correct. When drawing you need to ask yourself the question how many times is the head, say, measured into the rest of the body length etc.

STAGE 2

The slope of Waffle's snout is level with the top of the ear in the photograph, so I lightly pencilled in a line for guidance. I made sure I had the distance between the nose and eye correct, measuring this by comparing it with the distance between the eye and the beginning of the ear nearest the forehead. Then I started to draw in detail. I drew in guidelines to indicate where the colour changes occur. For example, on Waffle's chest there is a line of long black wavy fur, so I planned out the areas of dark and light colour. It is a mistake to colour 'as you go' and my advice is always to plan out your picture carefully first. After I had completed this I walked away from my easel for five minutes. When I returned to the picture I knew that any inaccuracies would be far more obvious to me looking at it anew.

STAGE 3

With a Sepia pencil I lightly coloured in the ear, eye and nose, including the fur around the nose, using short strokes in the direction of the fur growth. For the first colour for Waffle's short wiry coat I put the basic colour down with short vertical and horizontal strokes, similar to cross-hatching. I kept the pressure on the pencil very light. Using Black I coloured all the dark areas of fur, lightly laying down the colour, again using two-directional strokes so that the colour was even. Then I began to move the pencil strokes in the direction of the fur growth. Here I used short one-directional strokes and where the fur is long and wavy I worked the pencil rapidly, making almost circular movements.

STAGE 4

I continued to work lightly, applying extra layers of colour until I had built up darkness on all the dark toned areas, but was careful not to overdo this.

Using Burnt Yellow Ochre, I pencilled in the colour of the dog's head and legs and various sections of body where this colour appears. The corner of Waffle's ear is a warmer colour, so I decided to use a little Burnt Sienna here.

Then I resumed work on the coat. I continued to lightly colour in the Black with short rapid movements in the direction of the fur growth. Where the fur is wavy I worked the coloured pencil as though I was actually pencilling in each curvy strand. Using this action soon build ups the effect of real fur, so I continued until I was satisfied that I had created enough tone and texture. For the very dark tones I cross-hatched a little. Cross-hatching with a light hand and a very sharp coloured pencil produces very subtle darker tones.

TIPS

o Do not apply too much pressure when using watercolour pencils. Too much pigment compressed on your paper will be impossible to erase.

o Be patient when building up texture. The process may seem laborious, but the texture will begin to appear if you persevere.

o Use a fixative spray to prevent pencil work smudging. Apply sparingly.

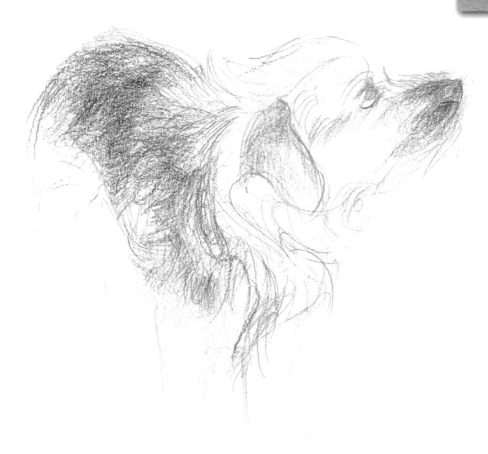

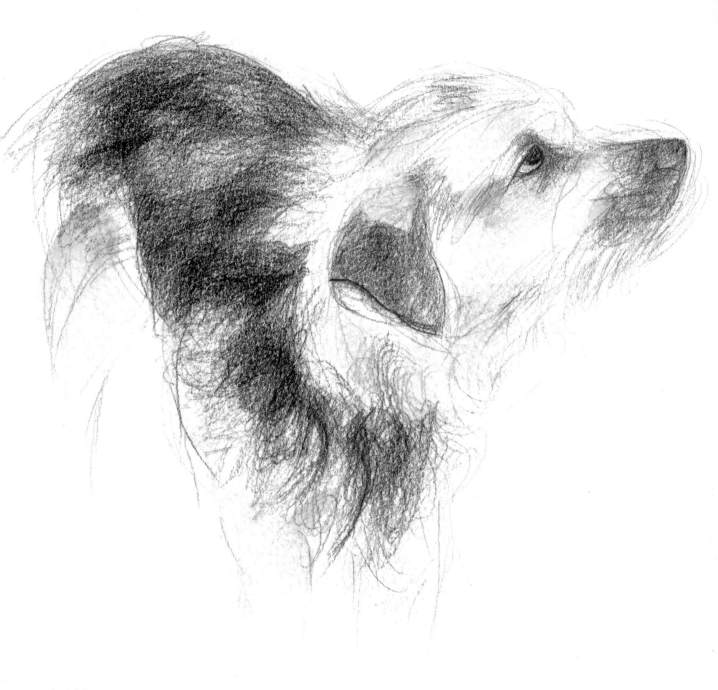

STAGE 5

I used a sharpened pencil to pick out the stray dark fur that appears
in the more yellow areas. I also drew in the long wavy strands at the
back of the head and on the chest. There was no need to pencil in
every strand, but doing it here and there gave the effect of wiriness.

I applied another layer or two of Burnt Yellow Ochre where the
colour is more dense, and here I used a little more pressure to the
areas where the long wiry fur is more obvious. To really emphasize
areas of flatter colour I took a damp size 000 brush and painted over
the strands of fur that were already pencilled in. I used this technique
sparingly because it can look overworked.

SMALL PETS

I have recently become more and more acquainted with small pets and this acquaintance has been and continues to be extremely rewarding. Even though guinea pigs, rabbits, hamsters etc. come under the category of 'small', they bring much pleasure and interest to any family unit. Children especially, of course, find small pets a great fascination and I have known huge bonds of love to exist between child and rabbit.

From an artistic point of view I never cease to be amazed at the vast variety of breeds of rabbits. Whether lop-eared, with upright ears, domestic or wild, there are many, many different shades, shapes and sizes that provide interesting subjects to draw and paint.

Some guinea pigs are quite spectacular looking, too, and it was through my acquaintance with the famous Olga da Polga that I discovered how domesticated these 'pigs' truly are. I did not realize just how different one guinea pig would be from another, but they each have their own individual personality and the difference in habits and behaviour can be quite marked!

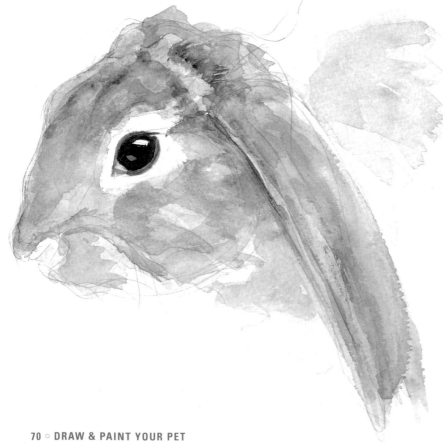

SHERLOCK

Sherlock is an extremely attractive rabbit, with long lop ears and lively bright eyes. Since his eyes give an inkling of his personality I painted the eye first, mixing Alizarin Crimson and Yellow Ochre for the rim to give a natural look. Soft tones of Payne's Grey with Lamp Black were used for the head, applied wet-on-dry.

Other small pets, such as the hamster, bring their own form of delight to children particularly. Drawing and painting these creatures' funny little faces always brings a smile to my face. These lovely little pets have offered great inspiration to many a writer as well as artist, as you can see in the films of Walt Disney and Warner Brothers, where their imagined characters are brought to life. I am sure these small animals will continue to be a source of inspiration.

Small pets are quite easy to simplify as a series of basic shapes compared to other larger animals. A mouse, for example, is delightfully simple because it can be drawn as a small circle. However, a rabbit or a guinea pig, being larger, is a bit more complicated since the anatomy is more obvious. Watch how these animals move and how they sit and rest. What is their favoured pose? Their movements are extremely rapid, so spend time making sketchbook notes based on their changing shapes as they run about.

The colours of small pets may be very subtle, especially with an animal like a hamster. However, you may also find colours that are extremely bold, as in a guinea pig that has a coat of great red and yellow furry rosettes.

Legs and feet for small animals can be tricky to draw accurately because they are quite intricate. Study them well and photograph them for reference.

BUTTERCUP

For this much-loved pet rabbit I applied Lamp Black wet-on-dry and Burnt Sienna for the lighter areas. I kept all the pigment well diluted and used a no. 11 brush, with a size 000 for the eye detail.

SWEETIE

This hamster's colouring is very delicate, so I used diluted Cadmium Yellow and Lemon Hue for his coat, with Sepia for shadows under his chin and cheek. I applied three layers of Lamp Black to the eye. Dab off some blackness with a tissue if the eye starts to look like a round black blob in a sea of yellow fur!

THE HIGHLAND RABBIT

This well-groomed and attractive rabbit is running wild in the Scottish Highlands, so I was told. He is such a beautiful colour that I am quite mystified as to how exactly he manages to camouflage himself. Judging by his fairly rotund appearance he is thriving! This pose has straightforward and simple lines and is one that I think you may particularly enjoy undertaking for yourself.

MATERIALS

300 gsm (140 lb) watercolour paper, cold pressed

HB pencil

Putty eraser

Watercolour brushes:
no. 8
size 000

WATERCOLOUR PAINTS

Sepia

Cadmium Orange

Yellow Ochre

Burnt Umber

Burnt Sienna

Alizarin Crimson

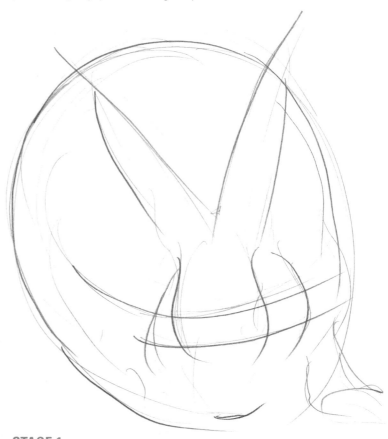

STAGE 1

With an HB pencil I lightly drew a circular shape for the main body. Notice the outline of the head and ears – the ears make a simple a 'V' shape. Once I had these structural lines down accurately I could continue the drawing by adding a bit more detail.

I usually like to start with the eyes and, although these were not obviously visible in the photograph, they will, of course, bring the painting more to life. This rabbit's eyes are surrounded by dark markings, which trail down from his spectacular ears to around his nose. Before moving on to the painting stage I made sure I mapped out the markings – mistakes are more likely to occur if you depend on painting the different areas 'as you go'.

STAGE 2

With a no. 8 round brush I painted in the markings in well-diluted Sepia. After placing a large block of brown colour I used a size 000 brush to draw the paint out from this main area, feathering the marking out towards the eyes and base of the ears. For other areas where more brown marking was visible, I added more paint with the no. 8 brush, then left this to dry.

I applied a watery Yellow Ochre to the main body, including the ears and head. As this was drying I applied Sepia again to the darker toned areas of this colour, using the no. 8 brush. You could also use the tip of a larger brush where the fur tends to taper out or you could use a size 000 brush. I usually prefer a very fine brush to indicate individual strands of fur.

STAGE 3

After this had dried I applied diluted Burnt Umber and Burnt Sienna for the areas of warmer colour. I then applied diluted Burnt Sienna and diluted Cadmium Orange alternately to the rest of the body and head area and continued to build with overlaying washes of these colours until I had achieved the required depth. This took about three layers.

Finally, I added the little surrounding line of pinkness around the visible eye. For this I mixed up Alizarin Crimson and Yellow Ochre.

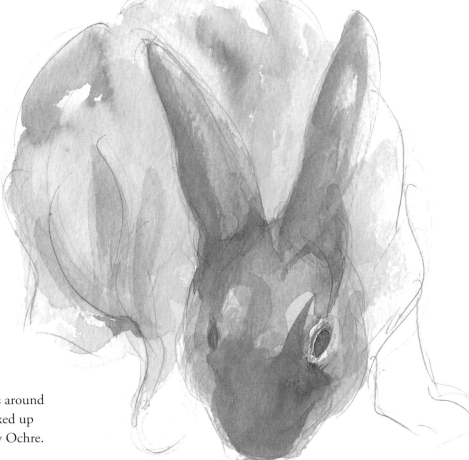

This engaging rabbit makes the perfect subject for watercolour pencils. Sparkle is mostly a grey rabbit, but there are some lovely colour variations in his fur and this close-up photograph gives the opportunity to see all the colour gradations. I used three different grey watercolour pencils as well as Sepia and Black. His fur is quite long and very dense and I used white pastel to create an impression of the thickness. Pastel can be a little messy to work with, so I applied it carefully and avoided getting it onto areas of the picture where it was not required. I found this an extremely satisfying drawing to produce.

MATERIALS

300 gsm (140 lb) watercolour paper, cold pressed

HB pencil

Putty eraser

Watercolour brush: size 000

WATERCOLOUR PENCILS

Ivory Black

Blue Grey

Silver Grey

Sepia

Rose Pink

Gunmetal

Chinese White

White pastel

STAGE 1

Sparkle's basic shapes are simple to discern, being made up of a series of curves. You can see how the guidelines I put in really helped me line the features up. The nose is extraordinary in its shape, with a patchwork appearance that is quite cartoonlike, as are the eyes in their extreme roundness. This was an attractive pose to draw, with one ear in view and the other slightly out of sight. By laying down the basic shape well with a loose, unlaboured feel about it the work that proceeds from here on, although extremely detailed, should also possess a free style.

STAGE 2

With an Ivory Black pencil I coloured the
black pupil, using short cross-hatched
strokes, then used Sepia for the
dark brown of the eye. I
outlined the shape of
the nose with Sepia and
Ivory Black and applied
Sepia all over it, again cross-
hatching for the darker tones. I
extended the Sepia to the muzzle, and
gently worked the pencil into the paper with tissue
before building up more colour on top of this smooth
surface. After working on all the brown tones of the face I applied a
Blue Grey colour, always working the pencil in the direction of the
fur growth.

STAGE 3

I built up the fur, using each colour alternately, first Sepia, then
Silver Grey, then Blue Grey, by working over and over it. The brown
is quite dense on Sparkle's ears, so I applied Sepia in side-to-side and
diagonal movements until it formed the base colour.

I used Rose Pink for the just visible inner ear. I applied Gunmetal
very lightly to create whiskers, but if you feel they are not visible
enough, at the end you can paint them in with a size 00 brush
using Chinese White. Be careful not to make the whole
whisker line white, but vary it as these whiskers
are reflecting dark.

Pastels are an extremely good back-up
if you want to create a rich amount
of pigment when doing pencil
work. I used white pastel for
the outer regions of
Sparkle's muzzle
and around the
eye and top of
the ear,
easing it into the paper and other
colours with a tissue. As I was not achieving
the depth in the eye colour that I wanted, a
dampened size 00 brush helped ease the pigment into the
pupil and the rest of the eye including the rim.

OLGA DA POLGA THE GUINEA PIG

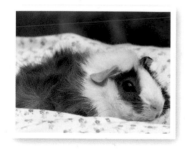

I was very honoured when I was commissioned to draw the portrait of this very fine and well-known guinea-pig and I could not complete this book without adding Olga to my gallery of pets. Meeting her was a delight and undertaking her portrait in watercolour pencils was equally so. Her beautiful rosettes of wiry fur can be built up gloriously with coloured pencil. Olga's ears flap over, and one is pink and one black. The black one is almost out of view in the photo, but can just be seen. I found it amusing that they become redder the more active she is. So the more she is gadding about, the more red they look. However, she was quite calm when I met her, so they remained an understated pink!

WATERCOLOUR PENCILS

Burnt Yellow Ochre

Burnt Sienna

Deep Vermilion

Orange Chrome

Rose Pink

Ivory Black

Burnt Umber

Silver Grey

WATERCOLOUR PAINT

Lamp Black

STAGE 1

Drawing Olga involved two basic oval shapes, one for her body and a small one for her head. I drew a guideline to show how the ear, top of the eye and edge of the nostril line up. The guidelines in the head also help to give a sense of form, creating the impression of three dimensions. As Olga's dramatic fur formation takes over her body shape, this could be also worked in within the guideline I marked. Even a simple drawing like this requires careful planning.

The lines here are heavy for the purposes of demonstration, but usually I keep them fairly light so that they can be erased easily when painting. Also I try to keep the paper clean and free of smudges.

<div style="border:1px solid">

TIP

- - - - - - - - - - - - - - -

o If you are not confident in drawing fur with watercolour pencils try to devote a whole day solely to this technique.

</div>

STAGE 2

I pencilled in where white fur meets with ginger and the various tufts of fur. Olga has a ginger mark covering her eye, so I outlined this as well as her delicate pink nose. Her muzzle has quite a squareness to it, so the lines I marked would help me form the correct shape at this early stage. Olga's bright eye looks big in relation to the rest of her, which contributes to her general attractiveness! I also indicated the black line of fur at the edge of her face on that side.

STAGE 3

With a sharp pencil I started to lay in the darker tones on Olga's body and face, using Ivory Black first, followed by Burnt Umber. I laid down the colour very lightly in small rapid movements, working backwards and forwards to build up the fur. For the eye I put down the colour very softly with a Black pencil, leaving a white circle of paper for the glint. I used Black for the fur sticking out on the other part of Olga's face, then applied Burnt Yellow Ochre as the next colour for her fur.

STAGE 4

I applied Burnt Sienna to Olga's face and body. I kept the pencils very sharp all the time and used small rapid strokes in the direction of her fur growth. The various tufts are very clear to see, but it is important to keep the pressure very light always when doing this sort of drawing. I continued to build up this colour in various parts of her fur, but varied it according to the dark and light tones I noticed on her body.

The more you work one layer over another, the more you will see the effect of fur being built up. I tend not to cross-hatch very much when working on fur, except when the tones are extremely dark and then only with a very light touch.

I applied a light Rose Pink to the nose and ear. You will see that the ear furthest from view has a black overflap. I mixed the pink here

An alternative way to portray Olga's eye is to use a fine size 000 round brush to apply a little Lamp Black watercolour paint to the eye area. I usually prefer this method as I think the effect looks livelier, but it is entirely up to you and how comfortable you feel with either medium.

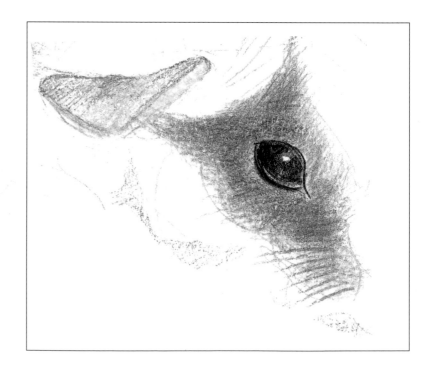

with a touch of Burnt Yellow Ochre to give it a little more warmth.

STAGE 5

For my next fur colour I used Orange Chrome. You can see how effectively the different shades build up the impression of fur. To emphasize the orange fur growing into the white, or the white growing into the orange, I just used a sharp pencil and applied a little extra pressure, but kept the movements short and sharp.

I built up the eye colour with a size 000 brush and watery Lamp Black watercolour paint. If I had wanted to do this dry I would have used a sharpened Black pencil and applied another layer or two here. I used a Black pencil to define the outer edge of Olga's face.

I then applied Deep Vermilion to the areas of the coat where the colour is warmer and continued to build up this colour lightly. If you apply too much pressure on the paper with coloured pencil the fur effect looks laboured and unconvincing. I applied Silver Grey for the areas in shadow – that is, for her neck area and also the fur at the top of her head – using the pencil for subtle outlining.

Then I took a short break and when I returned to my easel I touched up any areas that I felt needed a little more emphasis. As usual the golden rule is not to overwork a picture. Finally, I drew a fine pencil line to suggest a cushioned bed for Olga.

TIPS

o Keep discarded pieces of watercolour paper because even corners are useful for practising on.

o Get a feel for the medium of watercolour pencils by laying down some colour, then painting over it with a damp brush.

o If you want to mix two colours simply lay down one colour and cross-hatch over it with another.

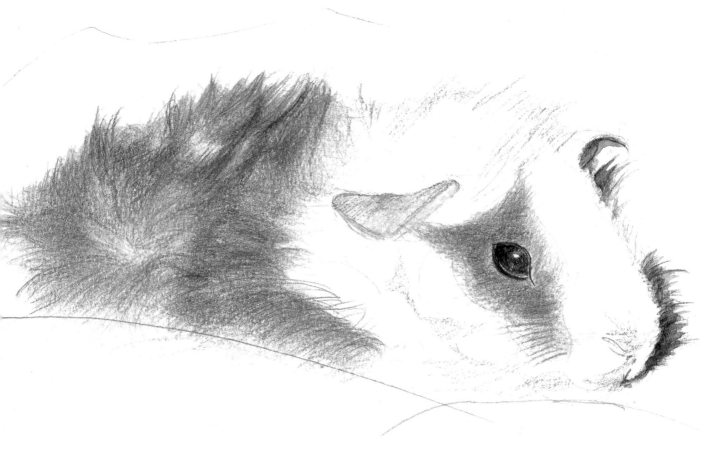

HORSES

I have always had a great love of horses and, having been born in Suffolk to a father and grandfather who worked with these noble creatures, I developed a deep interest from a young age. Whether a spirited Arab or a docile work horse, each animal has its own marked beauty in motion or standing still. Once you have mastered the skill of drawing horses you will find this to be an immense pleasure.

I have found attending racehorse meetings very useful because racehorses make ideal models – they are so lean that all the important muscles can clearly be seen! This is a great help to the artist who is trying to come to grips with the anatomy of the horse.

With this in mind, I suggest you get started with the head first of all, and so I have chosen to demonstrate the head from two different angles. When you have become confident with this, then it is up to you to take the next step and begin sketching the full body.

PAVLOVA

pencil

This is a pencil drawing of Pavlova, a fine racehorse. It is a good exercise in control to practise using pencil not just for sketching, but also for making more finished drawings. This horse has a body shape that displays her wonderful musculature well. Racehorses are clipped, so there is a beautiful sheen on her coat.

The main problem when drawing a whole horse is getting the proportions correct. Again, I find that the head is a good measuring unit and you can use this to see how many heads make up the body length and height. The legs can be difficult for a beginner as you need to make the muscle line appear unlaboured. Practice will get you there, however, and especially if you can draw from the live animal. No matter how good the photograph there is nothing like standing in front of a real horse. It is a joy then to make sketchbook notes because horses are so big. Their musculature is extraordinarily powerful and you need to draw the curves of these muscles convincingly to give a horse any substance.

Horses' coats normally have a very smooth appearance. It is always best to start painting the darker tones first, so you will need to look at the lights and darks in your subject. What direction does the light come from, how do the shadows fall and what other colours are seen in the coat when in direct sunlight?

Drawing horses is not easy really, but then nor is drawing any animal. In fact each animal I have drawn and painted for this book has required its own special approach, and drawing and painting horses is no exception.

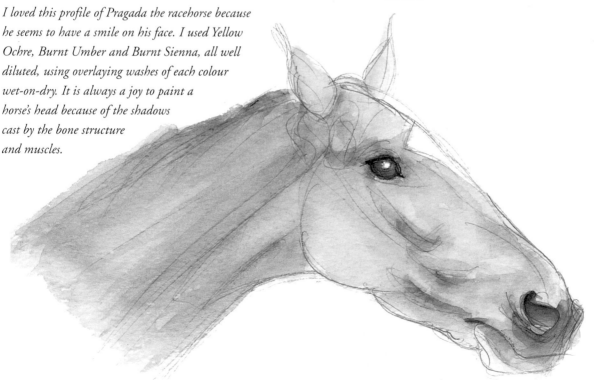

DOMINO

I have included a donkey because these animals have such beautiful faces and altogether possess a charm that is irresistible. I used watercolour paint because I wanted to demonstrate just how excellent size 00 brushes are for the fine detail of the individual strands of fur in his ears.

PRAGADA

I loved this profile of Pragada the racehorse because he seems to have a smile on his face. I used Yellow Ochre, Burnt Umber and Burnt Sienna, all well diluted, using overlaying washes of each colour wet-on-dry. It is always a joy to paint a horse's head because of the shadows cast by the bone structure and muscles.

PRAGADA THE RACEHORSE

I wanted to demonstrate racehorses as the main study in this chapter because these animals are in such perfect physical shape and it is very clear to see the muscles throughout the body. Pragada has been quite a star in the racing world and, though now retired, has clearly thoroughly enjoyed his athletic calling.

MATERIALS

300 gsm (140 lb) watercolour paper, cold pressed

HB pencil

Putty eraser

Watercolour brushes:
no. 11
size 00

WATERCOLOUR PAINTS

Sepia

Lamp Black

Burnt Umber

Burnt Sienna

Yellow Ochre

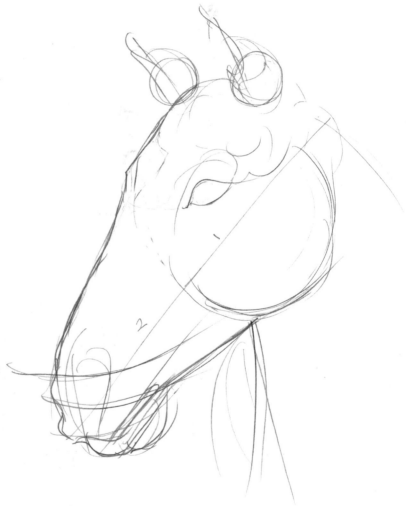

STAGE 1

With an HB pencil, I lightly sketched the general outline, using guidelines to check that all the features are in proportion at this early stage. Horses' heads vary dramatically from one to the other, so I made sure I worked out a measuring system before I continued with the next stage. Notice that the section I marked number '1' is the same length as the part numbered '2'. I also find the ears easier to contend with by putting in a little circle at the base.

STAGE 2

I started to put in more detail at this stage and I pencilled in the nostrils, eye detail and ears. There are many lines and shadows in a horse's head that display its strong musculature and bone structure, so I also pencilled some of these in lightly before beginning to paint. These make it easier to create form and dimension. I also put in guidelines for the ears. A horse's head is more complicated than most pets, so this was a good test of my drawing skills.

I indicated the marking on the forehead so that I could avoid painting this area, leaving the white of the paper showing through.

STAGE 3

With a no. 11 round brush I applied Lamp Black in a very watery mixture onto the darker shaded areas of the face and neck. For the eye I used a size 00 brush, painting in the rim first of all, then painting a basic foundation for the eye. I left this to dry.

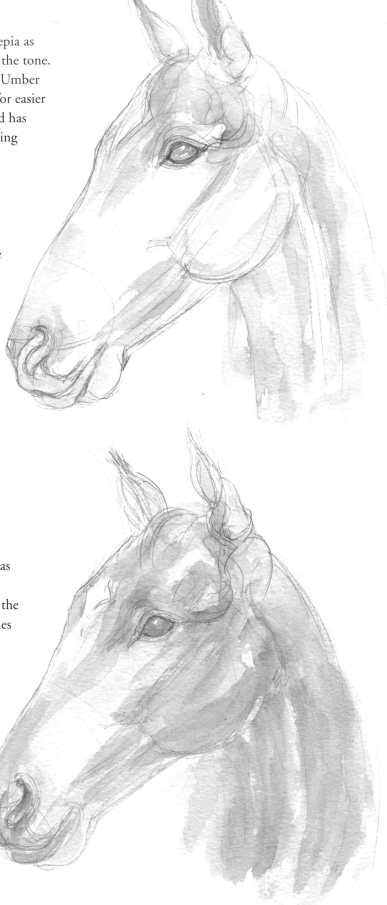

STAGE 4

Using the no. 11 brush, I applied Sepia as the next colour to start building up the tone. I continued the process with Burnt Umber with the same brush, using the tip for easier control. Notice how the horse's head has many beautiful muscles in it, throwing shadows on the forehead and upper cheekbone. These began to look dimensional as the layers of colour gradually built up.

I painted in the nostrils with watery Lamp Black, again using the tip of the no. 11 brush. Then I left the painting to dry.

STAGE 5

I darkened the brown and black areas with the tip of the no. 11 brush, making sure that I had included all the shadows cast by the beautiful muscles in Pragada's head.

When this was dry I used a size 00 brush with Lamp Black, Sepia and Burnt Sienna to strengthen and start shaping the eye. Again I left the painting to dry before continuing with the next stage.

STAGE 6

I applied Burnt Umber again and then, after this layer had dried, I applied Burnt Sienna and Yellow Ochre, making sure that these mixes were fairly watery.

I applied a little Burnt Sienna to the eye and let this dry. Then I applied watery Burnt Sienna to the face and neck, and let this dry. With a fine size 00 brush I applied Lamp Black to the nostrils, lips and inner ears. I continued to be careful always to work with watery paint so that I was not laying colour down too thickly. Gradually building up these subtle tones gave more form to the painting and I added more until I was happy with the result.

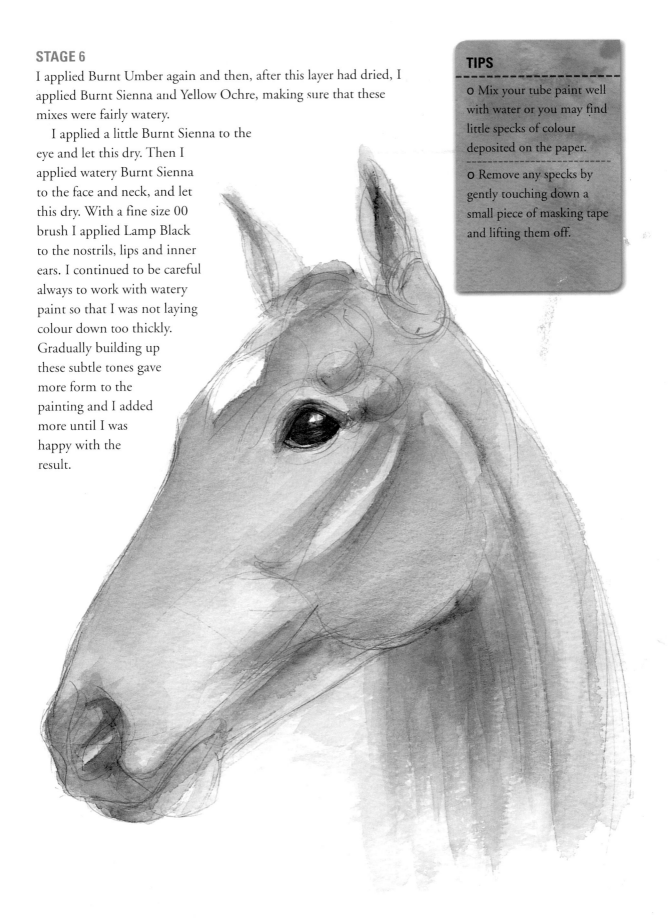

TIPS

o Mix your tube paint well with water or you may find little specks of colour deposited on the paper.

o Remove any specks by gently touching down a small piece of masking tape and lifting them off.

PAVLOVA THE RACEHORSE

Pavlova is the mother of the celebrated Pragada and is also a beautiful racehorse. Her distinctive long nose is beautifully straight in this pose, where she is almost straight on, facing the camera. Like Pragada she is gregarious, and enjoys her life and career to the full!

STAGE 1

I outlined Pavlova's head using an HB pencil. This was a very simple outline, so it was straightforward to do. Once I had drawn this I could start to put in the detail. I lightly drew in the eyes, which are extremely round and give a good clue as to why horses have such excellent rear vision.

I placed a number of guidelines so that I could start creating the impression of depth and form in the painting. These lines were also very useful in getting the proportions correct and lining the features up accurately. I pencilled in the nostril detail, ears and Pavlova's red fringe and mane.

MATERIALS

300 gsm (140 lb) watercolour paper, cold pressed

HB pencil

Putty eraser

Watercolour brushes:
no. 11
size 00

WATERCOLOUR PAINTS

Yellow Ochre

Burnt Sienna

Burnt Umber

Cadmium Orange

Lamp Black

Sepia

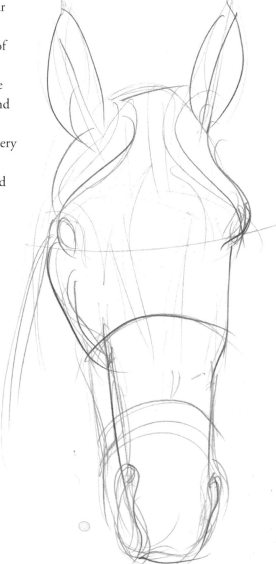

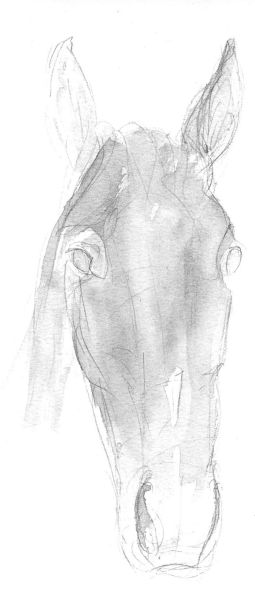

First I painted the darker tones with Burnt Umber with a no. 11 brush, then overpainted them with Burnt Sienna. I applied Yellow Ochre all over the head, followed by Cadmium Orange, keeping it well diluted. I let each layer dry before applying the next. With a couple of layers of each the painting began to take shape. I used a size 00 brush to paint the eye detail in Lamp Black.

I allowed the white of the paper to show through for the little white marking in the middle of Pavlova's head.

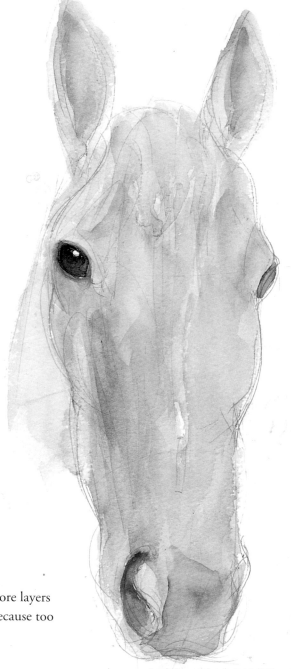

STAGE 3

I continued to apply further layers of paint to give realistic depth to the head, and added just a little more pigment to the water I took up on the brush. I allowed each layer to dry before applying the next. With a 00 brush I used Burnt Sienna for the horse's fringe and mane, indicating a few stray strands. I continued to use Lamp Black for the eye and then I used Sepia for the inner ear mixed with Lamp Black. I again used this mix to darken the nostril area.

I further darkened the nostrils and muzzle with Sepia. Then I added another layer of eye colour and let this dry. I continued to paint more layers where necessary, but was careful not to overdo this because too much paint can spoil the final effect.

BACKGROUNDS

Backgrounds can either make or break your painting and choosing the right setting for an animal is an important element in the composition of a picture.

If, like me, much of your work is produced on a commission basis then you will probably find you are asked to include no background at all or to put in a plain colour wash background. If the painting is to be shown in a commercial gallery on your own behalf the decision will lie with you.

DANNY IN THE PARK

This is a lovely picture of young Danny taking a breather before launching off to another adventure. The foliage consists of a few colour blobs really, but it was satisfying and fun to paint! I used Sap Green mixed with Cadmium Yellow and Viridian for the greenery, and Burnt Sienna for the twigs. This sort of background is ideal for a beginner as it is quite uncomplicated.

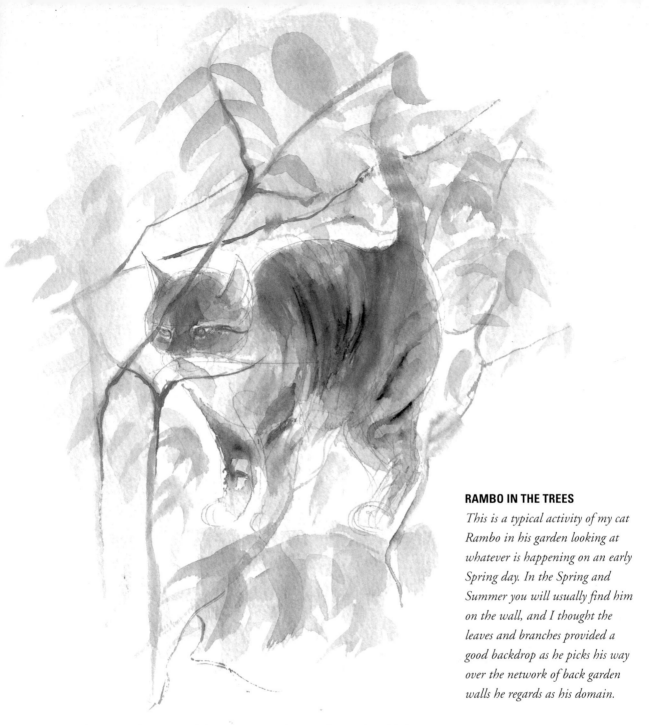

RAMBO IN THE TREES

This is a typical activity of my cat Rambo in his garden looking at whatever is happening on an early Spring day. In the Spring and Summer you will usually find him on the wall, and I thought the leaves and branches provided a good backdrop as he picks his way over the network of back garden walls he regards as his domain.

With watercolour pencil drawings I tend to work mostly with just a hint of a background, or no background at all. This medium involves working in a detailed style and, when this is the case, a background that is equally detailed or busy would definitely detract from the subject.

When using watercolour I find that I prefer a slightly 'unfinished' look to the painting and that this style also creates interest for the viewer, inviting them to create and complete in their mind what is happening in the picture. A good rule to follow, especially when working with watercolour, is summed up in the saying 'Less is more'. Watercolour is an excellent medium for subtle effect and the more

you work with it, the greater your expertise will become. This comes with practice, and yet more practice.

Obviously you should plan any painting well at the initial drawing stage, but this becomes even more important when you have a background to consider. Always start with a setting that you are happy to cope with. Do not undertake an intricate subject with a background that has a lot going on in it – this will just overwhelm a beginner, and even I feel daunted if I am faced with a commission request that looks complicated. Just practise first of all with, say, a light colour wash as your background and then when you are happy with that you can add in the odd blade of grass or other foliage.

BELLA AMONGST THE BLUEBELLS
Ann-Louise caught Bella as she pottered through bluebells and her photo inspired my painting. This picture was a delight to paint and the composition is quite different from much of my work. I used a mix of Cobalt Blue and Cobalt Magenta for the bluebells, and a Sap Green and Payne's Grey mix for the foliage.

It is best to progress gradually with watercolour and to take it a step at a time. Perhaps you are shaky on getting the right colour mix and, if this is the case, spend a day mixing up colours and painting on unwanted sheets of paper. This is the only way to move forward and if you do not follow this graded process of working you will become frustrated with your art.

Paintings can be broken down into light and dark tones and this is the best way to build up a painting. This is the method used in my demonstration of *Wee-Un in Shadow* on page 92. It helps you retain control of your picture and if you know exactly what you are doing and what your next action will be your confidence will soar. You will create works of art that give you a sense of pride and achievement. When you have reached this stage, pat yourself on the back. Painting can be hard work, but only hard work creates good results.

BELLA AS A PUPPY IN HER BASKET

Even as a puppy Bella had the characteristic orange splodge of colour on her flanks! Again, this is such an unusual pose that I decided to play down the details of the basket so as to emphasize the dog, placing Bella against a complementary background mixed from Payne's Grey and a touch of Phthalo Blue. Note that I allowed the white of the paper to stand for Bella's white fur.

WEE-UN IN SHADOW

I find it very satisfying to paint a pose like this, where the subject's face is part in shadow. Again, watercolour lends itself extremely well to this requirement as it allows you to add layer upon layer for depth. The brick wall was also interesting to paint – the bricks are over 150 years old and have a wealth of different colours in them.

MATERIALS

300 gsm (140 lb) watercolour paper, cold pressed

HB pencil

Putty eraser

Watercolour brushes: nos 3, 8 and 11 size 000

WATERCOLOUR PAINTS

Sepia

Cobalt Blue

Burnt Umber

Naples Yellow

Yellow Ochre

Sap Green

Lamp Black

Chinese White

STAGE 1

Wee-Un's head is definitely round and wide, so I started off with this general outline. Notice the guidelines I put in to line up her eyes. I also put in a smaller circular shape for her muzzle. A guideline from the middle of her head to the bottom of her chin helps create an impression of depth. I did not worry about detail at this early stage because I was concentrating on the overall basic structure. The painting could not proceed until I had achieved this.

STAGE 2

I pencilled in the eyes lightly – the guidelines helped me to get them level. As the photo was taken outside on a sunny day half of the nose and nostrils was in shadow, creating a dramatic look, so I indicated this in pencil. I lightly drew in the eyes and pupils, also half in shadow, which produces a subtle effect. The final part of the drawing stage was to pencil in the small wall plant and, of course, the bricks.

STAGE 3

As the sun is shining on one side of the cat's face I left some of the white paper showing through when laying down an initial wash of diluted Sepia on the darkest areas of the head.

Then I put a little watery Lamp Black in the very dark areas of Wee-Un's face, followed by another layer of Sepia to the other parts of her face and chest. For the lighter areas around her cheeks I used Yellow Ochre.

Then I applied watery mixes of Yellow Ochre to the wall and Naples Yellow for the wall plants and foliage. For the brick colour I used a mix of Cobalt Blue and Burnt Umber.

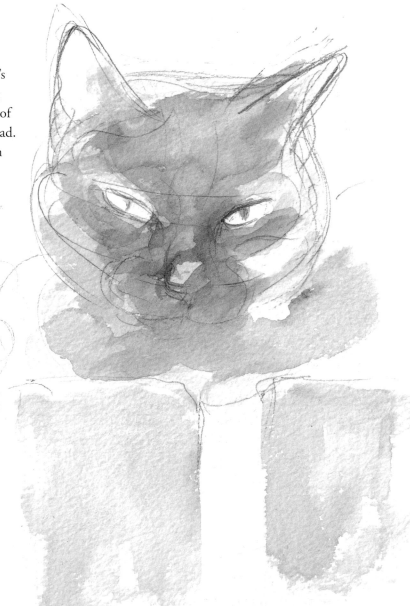

STAGE 4

I placed a further layer of watery Lamp Black on the very dark areas of Wee-Un's face. While waiting for this to dry I applied some watery Sap Green to the few leaves hanging above Wee-Un's head. With the tip of my brush and before the colour had dried, I used this newly applied paint to pull out leaf shapes here and there.

Dry brush technique was useful for creating texture for the wall. This involves using the brush briskly so that colour is laid down sporadically, leaving random specks of paper showing.

STAGE 5

I strengthened the Yellow Ochre on Wee-Un's face and fur. This was the final stage of the picture, so now I looked critically at my painting and applied small touches of white where needed to capture light and sun. If you find you have missed the opportunity to use the white of the paper for highlights when painting you can always use Chinese White.

I checked the small wall plant in case it needed a tiny addition of Naples Yellow or Sap Green. Then I looked again at the very dark shadows on Wee-Un's face and touched these up with diluted Lamp Black until I was happy with the total result.

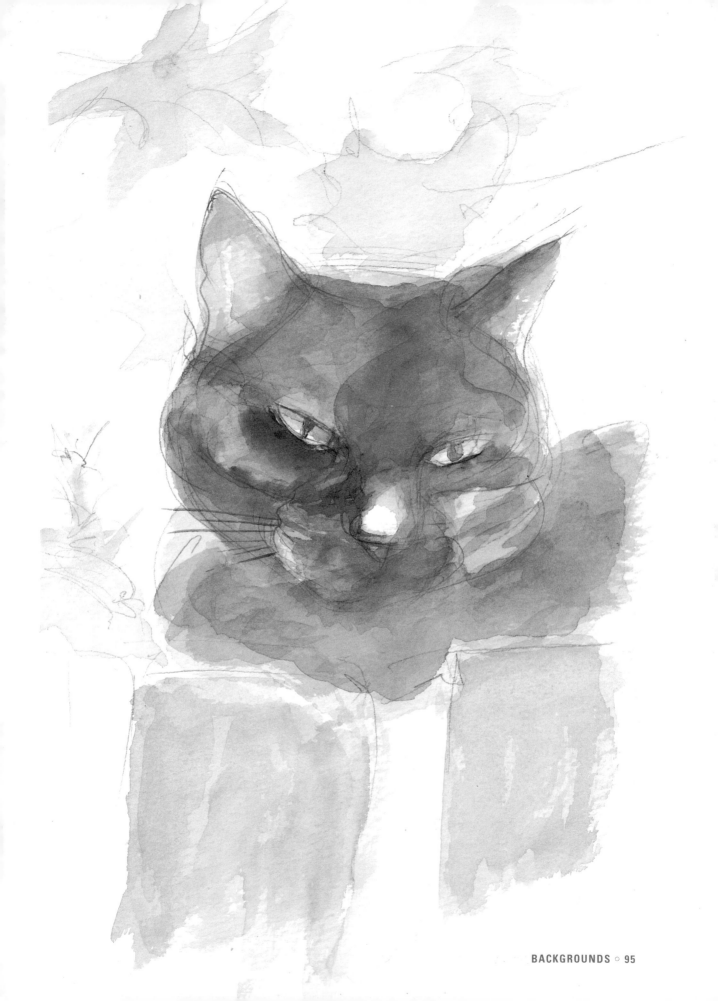

AND FINALLY ...

I hope that you have found this book useful, and that in your own application of the techniques I have described and demonstrated you will develop a skill that will lead you to the goal you have set yourself. Perhaps you will also find that this interest in drawing and painting your pet will develop into a passion and, as a result, you will develop a style that is your own and one that will be recognized and appreciated by many. This might seem a far-reaching concept to a beginner, but perseverance will eventually pay off.

Make sure you surround yourself with people who believe in you and who are supportive of your artistic interests. Be ambitious and do not accept any negativity as regards your aspirations in drawing and painting.

Keep your goal in mind and good luck!

George Vestey's silky coat and general appearance are quite the best I have ever seen. The pale colouring complements his rich dark eyes and facial markings beautifully. He has the bearing of a very well-bred dog and I found this captivating and inspirational.

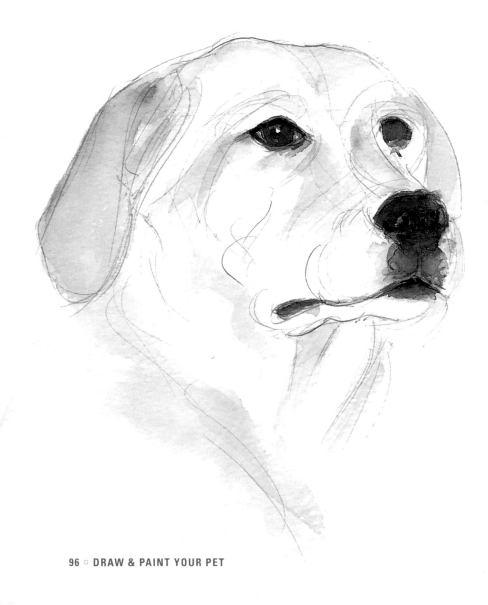